Contents

Palm-Sized Cats

Small enough to fit in your palm, these kitties
can accompany you anywhere—from adorning
your outfit to nestling in your bag.

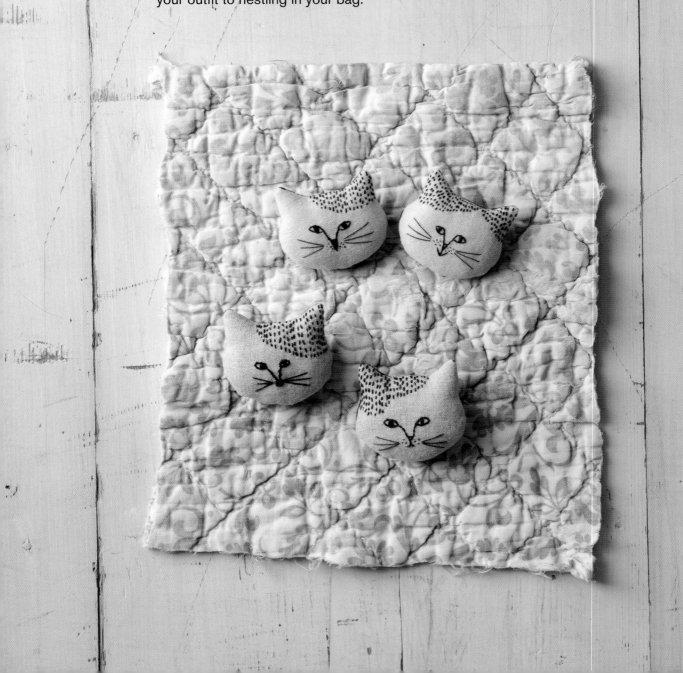

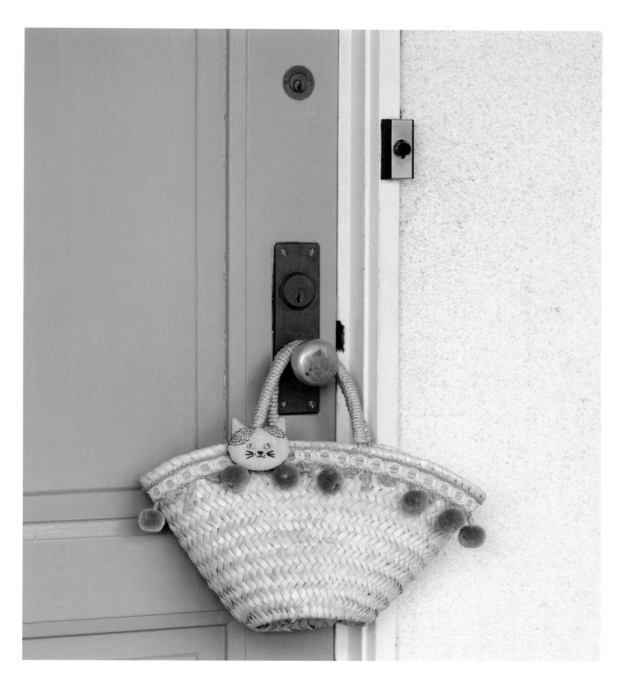

❧ Embroidered Brooches

Their expressions may look really serious, but they're probably just thinking, "I'm hungry…" Experiment with different facial expressions for these tiny cat-face brooches as you stitch them using a Sashiko-style embroidery method.

Design and construction by nekogao
Instructions + Templates + Diagrams → Page 50

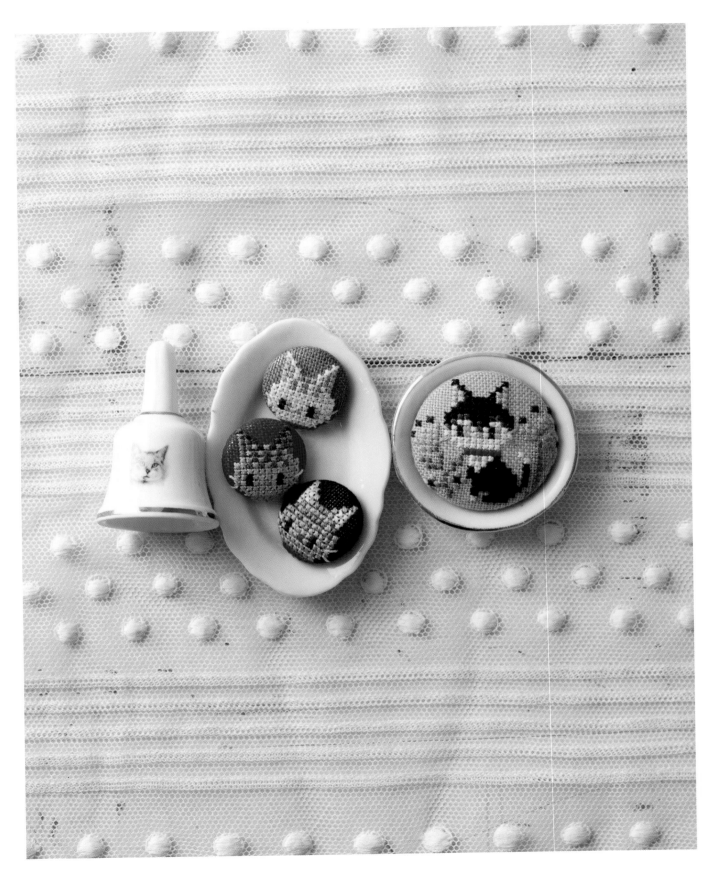

❧ Cross Stitch Buttons

Brown, white, black — so many different colored kitty cats!
These highly detailed cross stitch kitties even have little
markings on their fur! For extra adorableness, change up the
thread colors to match the special feline in your own life.

Design and construction by Kyoko Maruoka
Instructions + Diagrams → Page 18, 49

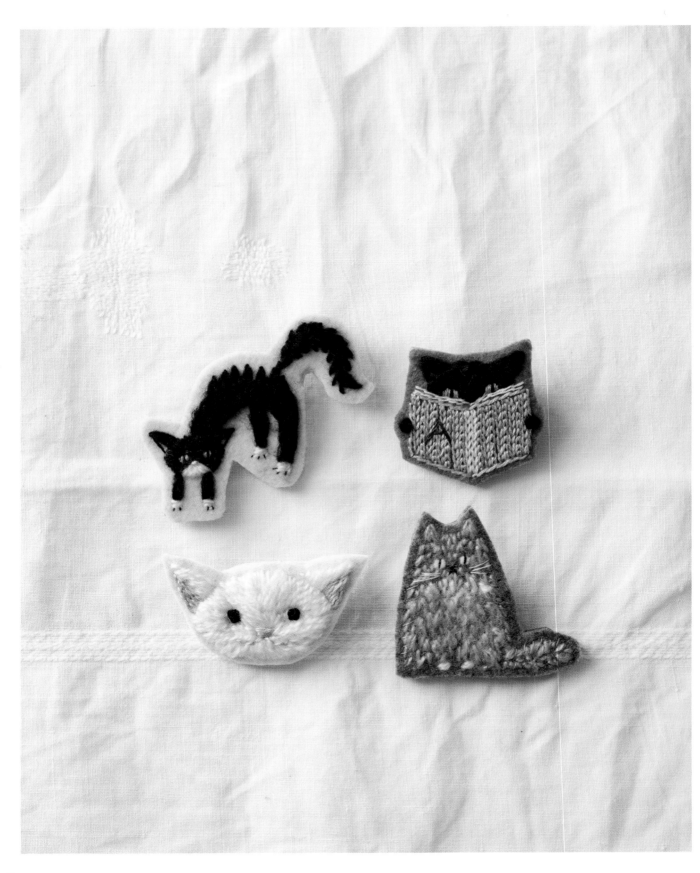

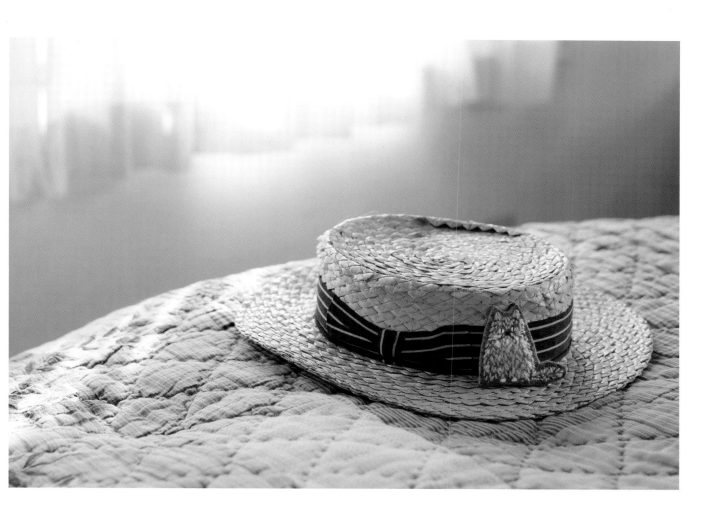

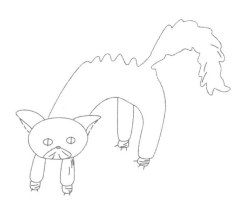

❧ Perfectly Embroidered Badges

From hissing felines to languorous furballs, cats come in many shapes and forms. Maybe there's even a bibliophile cat! Using mohair for the embroidery gives these cats a downy fur texture.

Design and construction by Mico Ogura
Instructions + Diagrams → Page 51

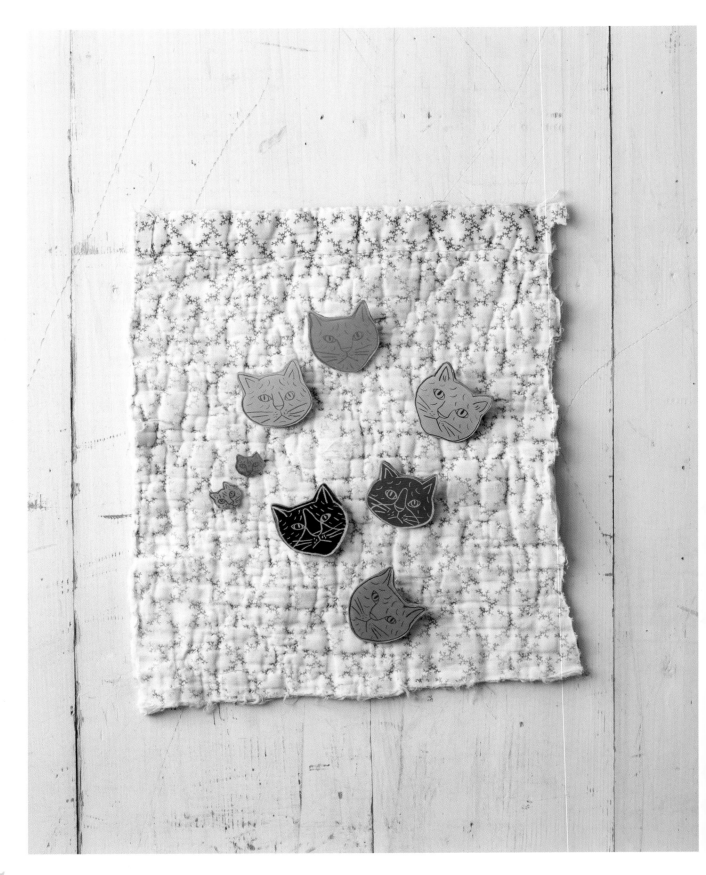

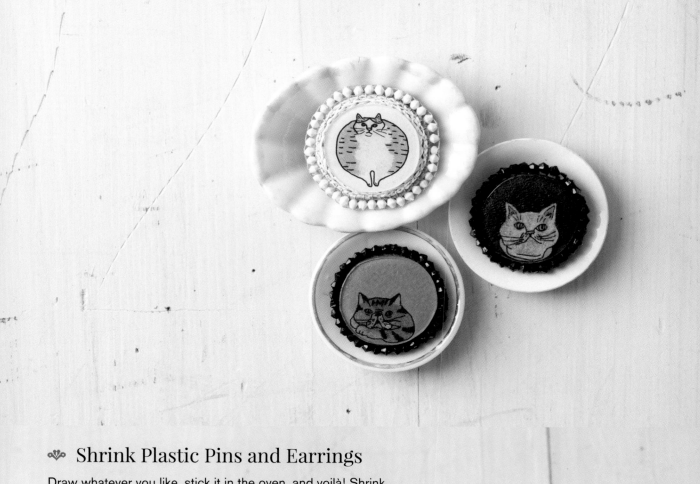

❧ Shrink Plastic Pins and Earrings

Draw whatever you like, stick it in the oven, and voilà! Shrink plastic is so easy and fun. Attach beads to the shrink plastic piece to make a pin or create two matching kitty earrings. The possibilities for accessories are unlimited!

Design and construction by minou14
Instructions + Diagrams → Page 20, 52

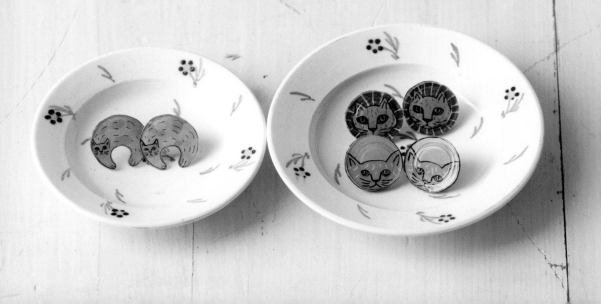

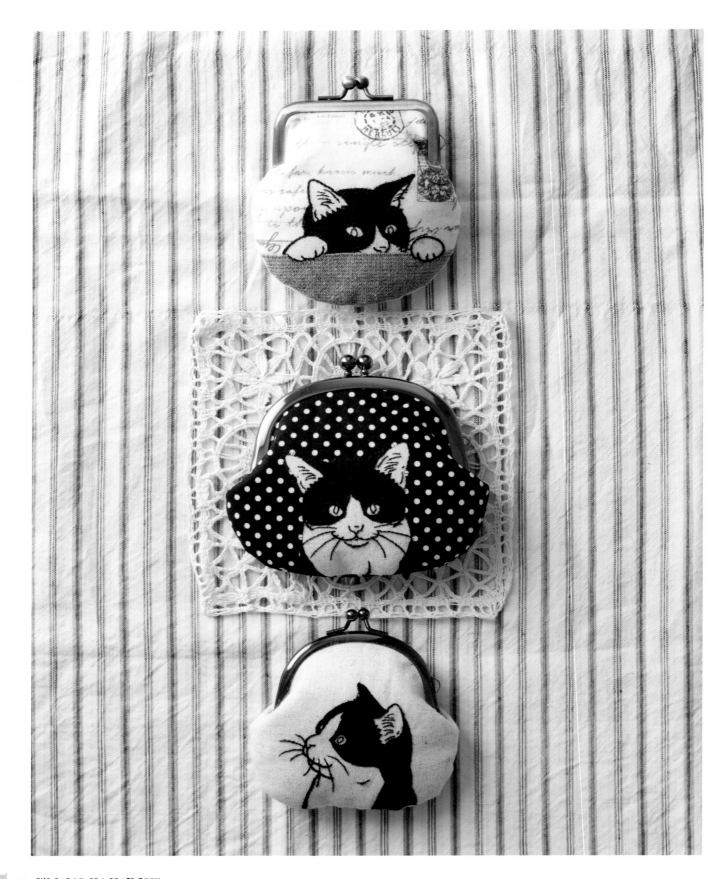

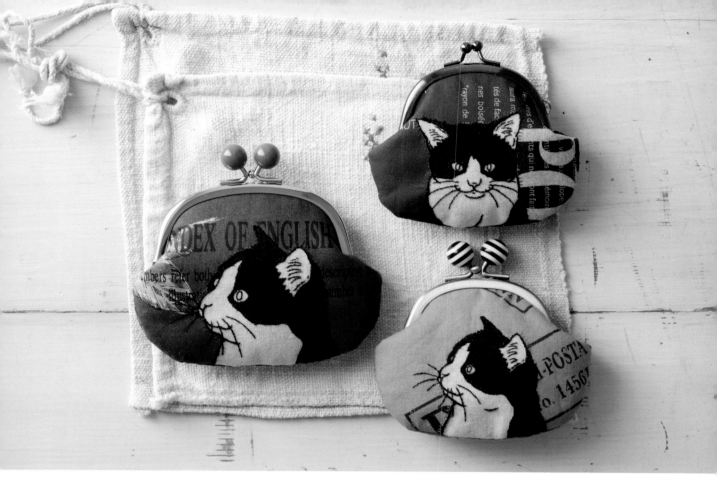

❧ Appliqué Coin Purses

These charming "Hachiware" cats have inverted "V" fur markings and require simple black-and-white appliqué. The raw edges are not turned under for this method, which calls for some patience but is entirely doable. The resulting cats are so realistic, you may be tempted to pet them!

Design and construction by Naoko Suzuki
Instructions + Patterns + Templates + Diagrams → Page 54

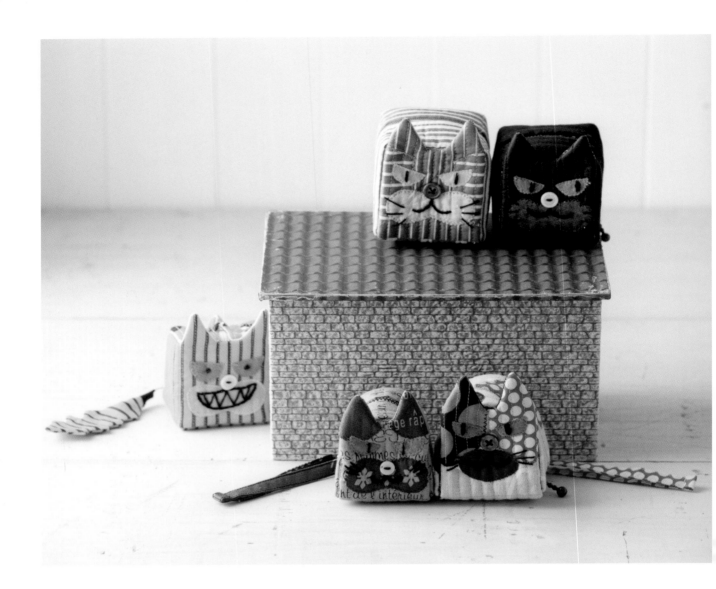

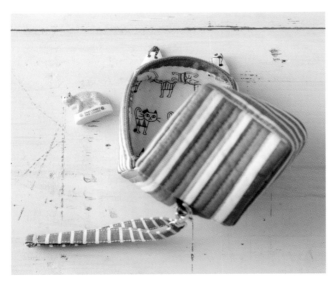

❧ Mini Mini Pouches

These roly poly pouches have sassy cat faces that are appliquéd and embroidered. You'll end up wanting to make a whole gang of these cheeky critters. Because the pouch opens flat, each pouch can have lots of uses.

Design and construction by Chizuko Kojima
Instructions → Page 40
Patterns + Templates → Page 58

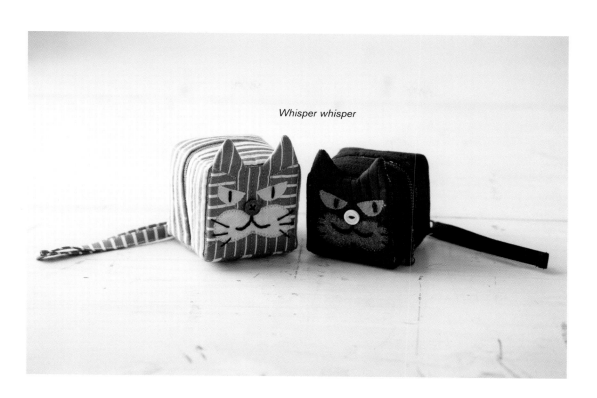

Whisper whisper

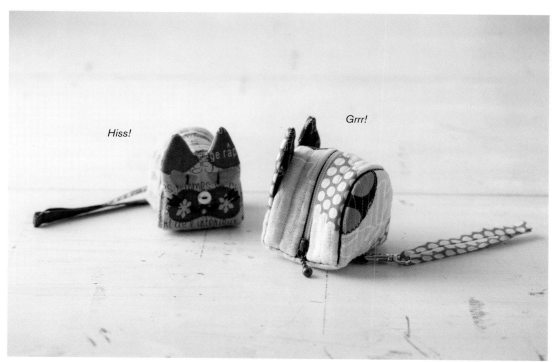

Hiss!

Grrr!

15

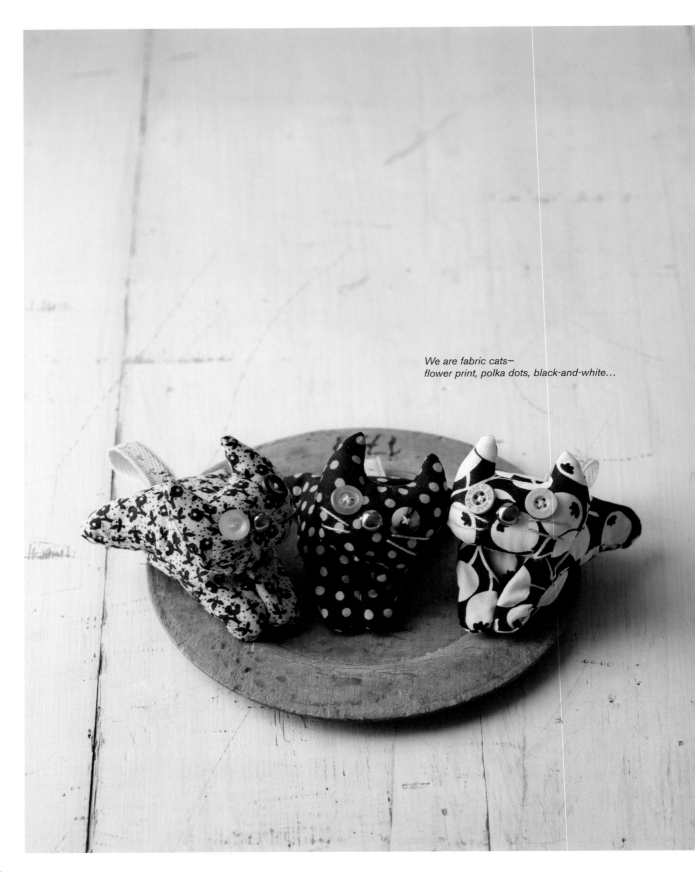

We are fabric cats—
flower print, polka dots, black-and-white…

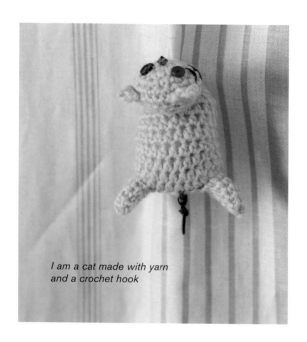

I am a cat made with yarn and a crochet hook

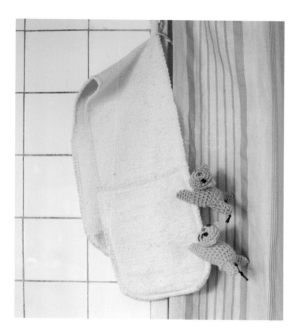

❧ Cat Clips

These cute clips have little paws that tenaciously grip. Use them to seal paper bags or hold cards or whimsically clutch and climb curtains…there are so many ways to have fun with them!

Design and construction by Yoko Kobayashi
Instructions + Patterns + Templates + Knitting Diagrams → Page 60

🐾 How to make the Cross Stitch Buttons on Page 6

Due to the smallness of the motif, this cross stitch (generally a time-consuming art) can be done in a snap. Refer to the diagram and stitch with care.

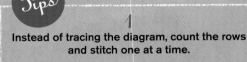
Materials

- ※ DMC #25 Embroidery thread…317, 924, 3852, 823, 648, 712, 959, 3706
- ※ Cross stitch fabric (red)…approximately 4 ⅜ x 4 ⅜ in (11 x 11 cm)
- ※ Covered button ⅞ in (2.2 cm) diameter…1

※ Thread the needle

This project will use double thread for embroidery. Since about 20 in (50 cm) is an easy length to handle, cut double the length to about 40 in (1 m). Fold the thread in half and insert one end into eye of the needle (double thread).

※ Start embroidering

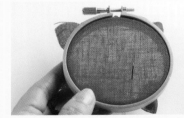

1. Place fabric in embroidery hoop. Keeping the size of the diagram in mind, target the lower right area of the fabric and insert needle from the wrong side (thread color 648).

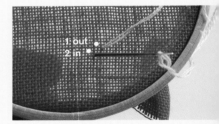

2. Pull out needle from 1, insert at 2

3. Flip over to wrong side, insert and pull needle through the loop at the tip of the thread to secure (loop method).

※ Continue stitching with the same color

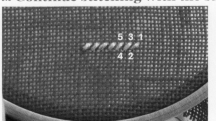

1. Begin by stitching the wide part of the face. Use thread **648** and consult the diagram as you stitch one row from right to left.

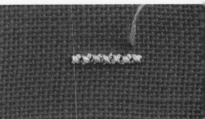

2. Next, stitch the same row from left to right, creating little crosses.

Embroidery Diagram
Fabric = Red

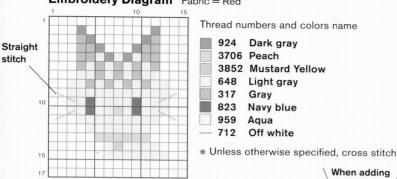

Straight stitch

Thread numbers and colors name

	924	Dark gray
	3706	Peach
	3852	Mustard Yellow
	648	Light gray
	317	Gray
	823	Navy blue
	959	Aqua
—	712	Off white

✳ Unless otherwise specified, cross stitch

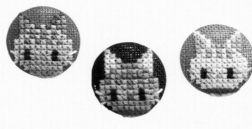

Finished size = ⅞ in (2.2 cm) diameter

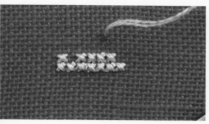

When adding thread

(WS)

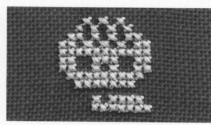

3. Refer to the diagram and continue all sections containing color 648, skipping other colored areas. Stitch one row from left to right, then alternate and stitch the same row from right to left.

4. When the thread starts to run out, insert the needle through 4 or 5 stitches on the wrong side then cut the thread. Secure the new thread as you did in step 3 and keep stitching.

5. Embroider the entire face and continue to skip sections with other colors.

✳ Embroider with the second color

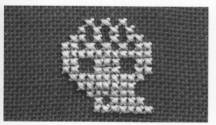

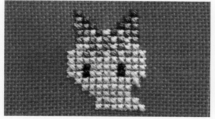

✳ Complete embroidery

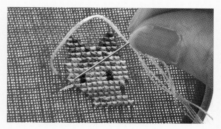

1. You can use any color for the second color. Here, we used 3706 for the collar and nose.

1. Embroider the rest of the cat: decorative pattern (317), ear line (924), eyes (823, 959), bell (3852.)

2. Embroider the whiskers (712). Use double thread and a straight stitch to form two whiskers on each side.

✳ Make covered button

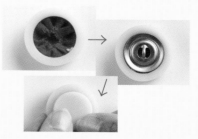

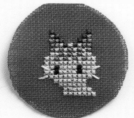

3. When you've completed all embroidery, press with a steam iron on medium heat.

1. Using the nose area as the center, cut into a circle of about 1⅝ in (4.2 cm) diameter.

2. Position the fabric around the button shell, making sure that the embroidered ears are not cut off and the cat is centered. Place face down inside the plastic assembly container (凹). Place the button back with the shank on top of the shell. Press the fastening piece (凸) from above to assemble button.

❧ How to make the Shrink Plastic Pins on Page 10

Once you learn the steps, anyone can easily whip up shrink plastic accessories.
We'll start with a simple cat face motif!

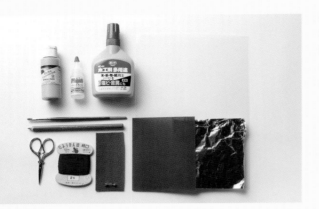

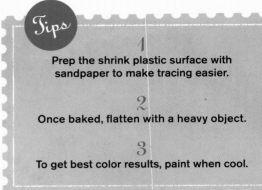

Tips

1 Prep the shrink plastic surface with sandpaper to make tracing easier.

2 Once baked, flatten with a heavy object.

3 To get best color results, paint when cool.

* **Please note!** There are a number of different shrink plastic brands on the market. Some recommend different materials and procedures for drawing, coloring and baking. Always read the instructions that are included with your plastic, always follow the baking instructions provided, and always take appropriate safety precautions when cutting and baking your plastic.

Materials

- ✂ Shrink plastic [(0.2 mm) thickness]... 7⅞ x 7⅞ in (20 x 20 cm)
- ✂ Dermatograph pencil (light blue)
- ✂ Acrylic paint (mustard yellow)
- ✂ Felt...2⅜ x 2 in (6 x 5 cm)
- ✂ Pin backs
- ✂ Handsewing thread
- ✂ Fine grit sandpaper
- ✂ Aluminum foil
- ✂ Brush
- ✂ Small scissors
- ✂ Woodworking glue
- ✂ Fray Check or similar
- ✂ Toaster oven or conventional oven

✂ Trace onto shrink plastic and cut

1. Prep the drawing side of the plastic by scuffing it with fine grit sandpaper. Evenly sand the surface vertically and horizontally until it looks white. Brush off the sanding dust.

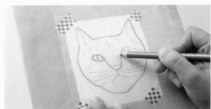

2. Place the shrink plastic on top of the templates and trace using the light blue Dermatograph pencil. Try to draw with clean, sharp lines. *Note that the templates are the reverse (mirror image) of the finished pieces.

Cut slowly with small scissors!

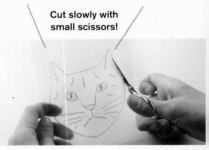

3. Trim just outside of the traced line. Carefully cut with small scissors. Trying to cut too quickly may result in cracks in the shrink plastic.

✂ Bake shrink plastic parts

1. Preheat toaster oven or conventional oven

All crumpled up!!

Crumpling the aluminum foil prevents the shrink plastic from sticking

2. While the baked parts are still hot, remove from the oven with chopsticks and place between the pages of a heavy book or something similarly weighty. Press from above to further flatten the shrink plastic.

Finished size = Approximately 1 ⁵⁄₈ in (4 cm) high x 1 ³⁄₈ in (3.5 cm) wide

Template → Page 53

※ Add color

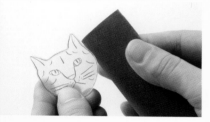

3. Check the edges once the cat has cooled, and sand down any rough areas.

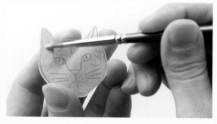

1. Add acrylic paint to the traced side (WS). You may need to paint a few coats for full coverage.

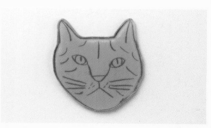

2. Wait for the paint to dry.

※ Create pin

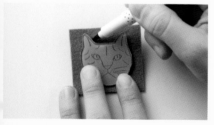

1. Place cat on the piece of felt and trace the shape.

2. Based on the traced shape from step 1, determine the position of the pin back and sew onto the underside of the felt.

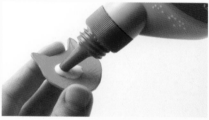

3. Spread a generous amount of woodworking glue on the wrong side of the shrink plastic cat.

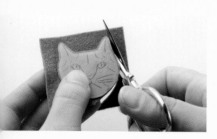

4. Glue the shrink plastic cat on the felt, matching up the traced line. Once dry, trim off the felt. Add Fray Check to the cut edges.

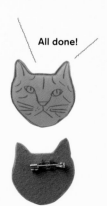

All done!

Back side

Use all your favorite colors to paint the cats

Go a touch mod with black and white, or try a feminine purple and pink combo. Have fun changing up the Dermatograph pencil colors for different combinations as well. Make it yours!

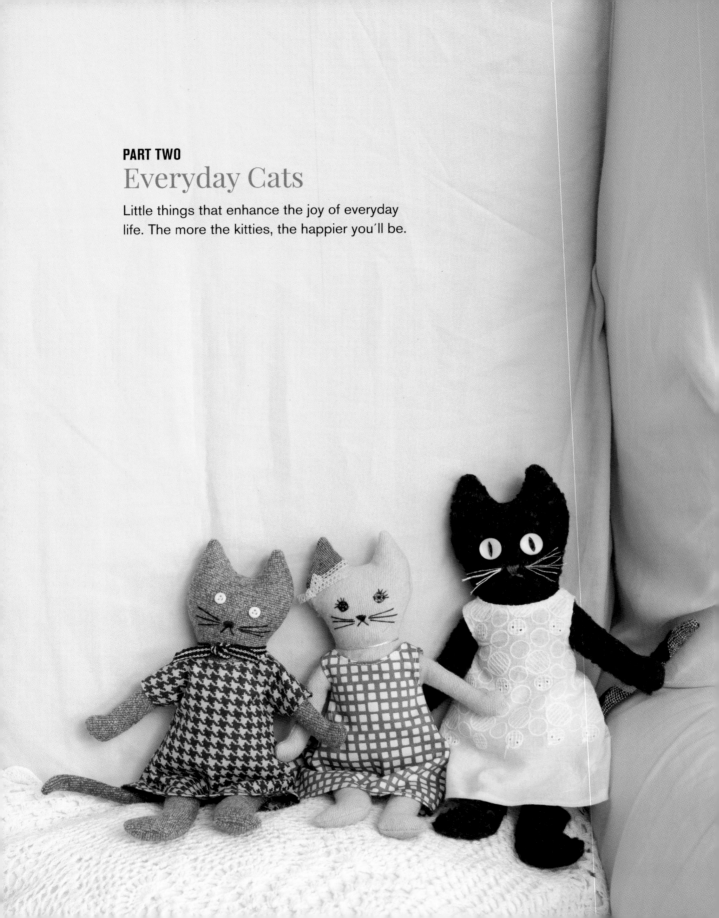

PART TWO
Everyday Cats

Little things that enhance the joy of everyday
life. The more the kitties, the happier you'll be.

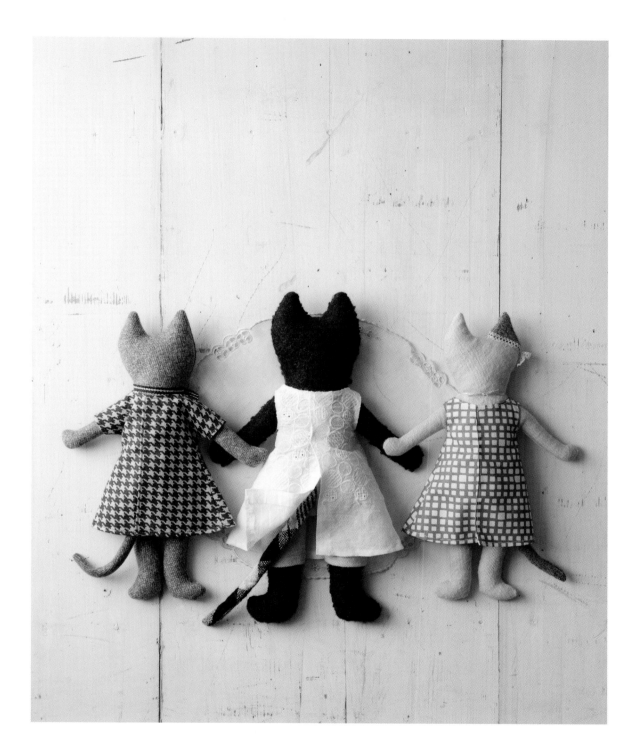

❧ Cat Dolls

Three stylish cat sisters showing off their pretty dresses and
lovely long tails. The dresses are just two pieces of fabric sewn
together; infuse them with love using slow hand stitching.

Design and construction by Hitomi Hanaoka
Instructions + Patterns + Templates → Page 62

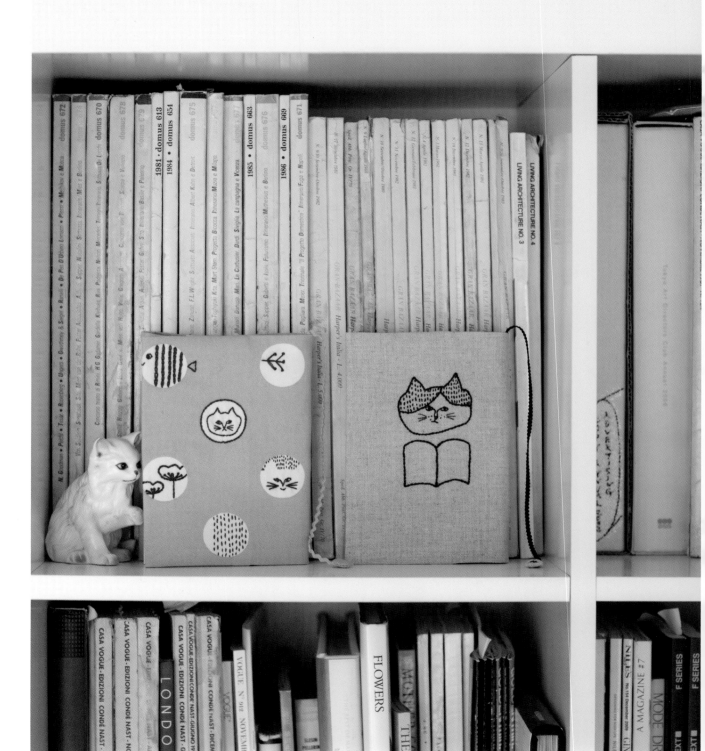

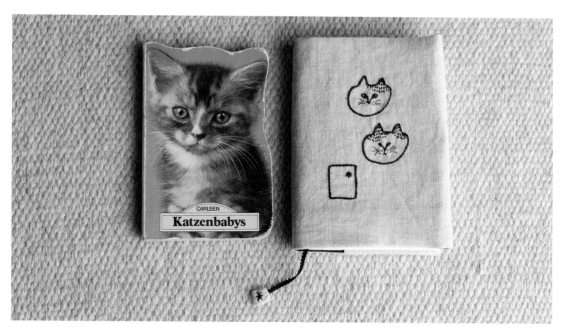

❧ Sketched Book Covers

Happy-go-lucky cat faces grace these embroidered book covers.
The bubbles morph from cat to fish to flower…like little feline
daydreams. A perfect accompaniment for those lazy reading days.

Design and construction by nekogao
Instructions + Diagrams → Page 66

❧ Cat-Shaped Door Stoppers

A pair of sweet patchworked kitties. Contrary to their whimsical appearance, these are hardworking cats, standing guard as the real-life cats sashay in and out of the door.

Design and construction by rie
Instructions + Patterns + Templates → Page 64

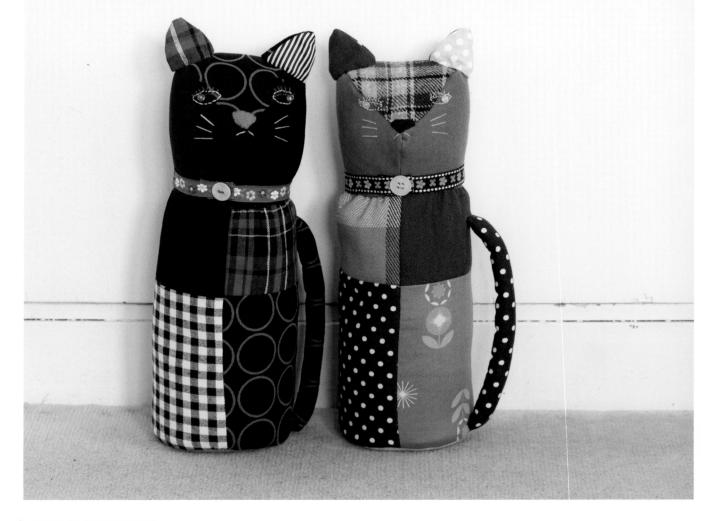

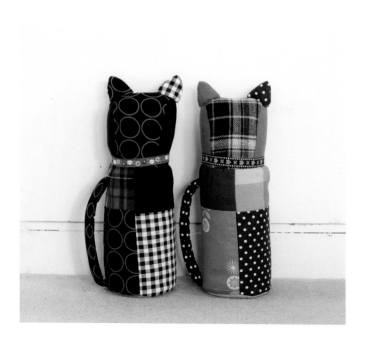

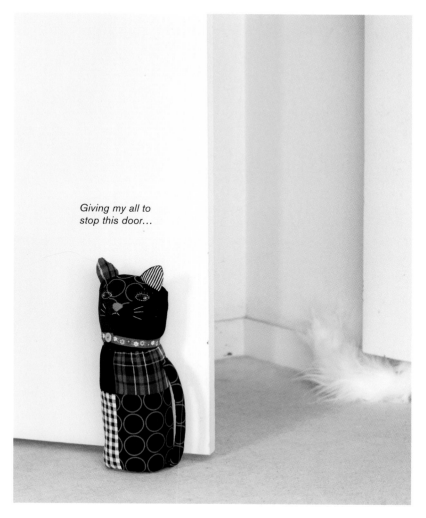

*Giving my all to
stop this door...*

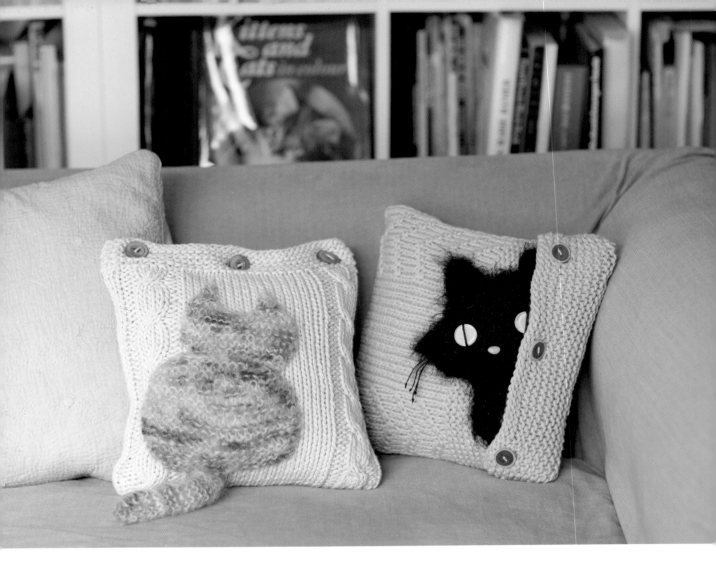

❧ Knitted Pillows

Soft knitted pillow + fluffy mohair kitty = the kind of pillow
that makes you want to bury your face in it and take a nap.
The extending tail is an extra sweet touch.

Design and construction by Kanade Isshiki
Instructions + Knitting Diagrams → Page 68

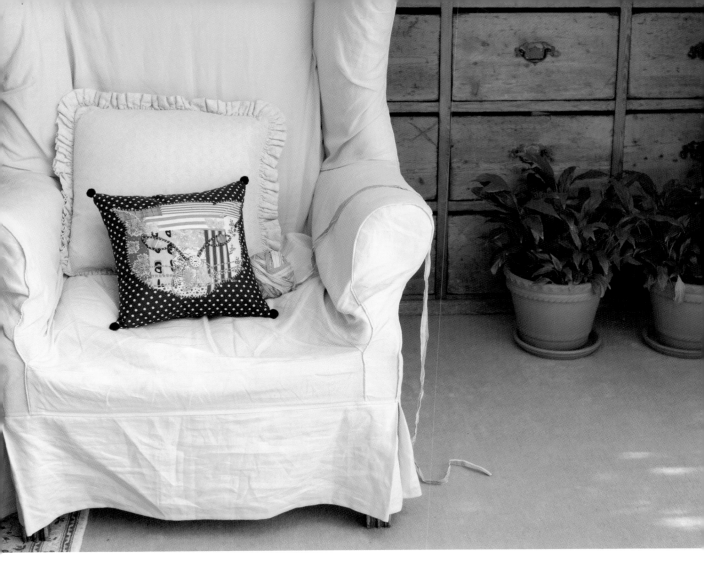

❧ Patchwork Pillow

Create a "cat pattern" from scrap print fabrics. Outline the face with the coaching stitch to give it ample definition and you have a beauty. Wouldn't it make a perfect accent piece for a room?

Design and construction by Yoko Kobayashi
Instructions + Patterns + Templates + Diagrams → Page 70

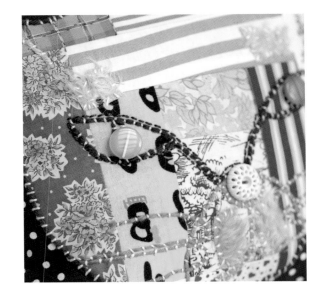

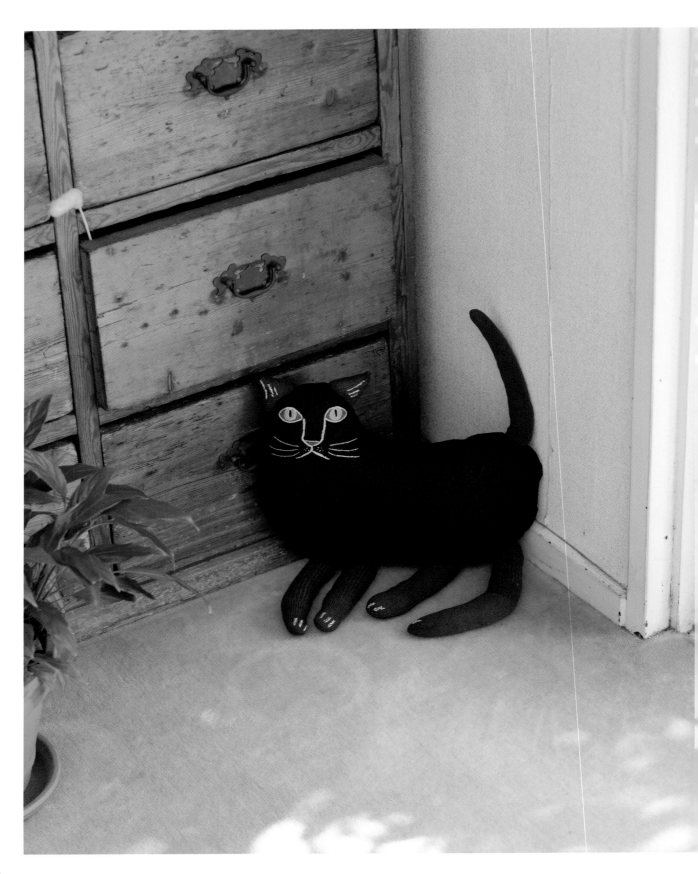

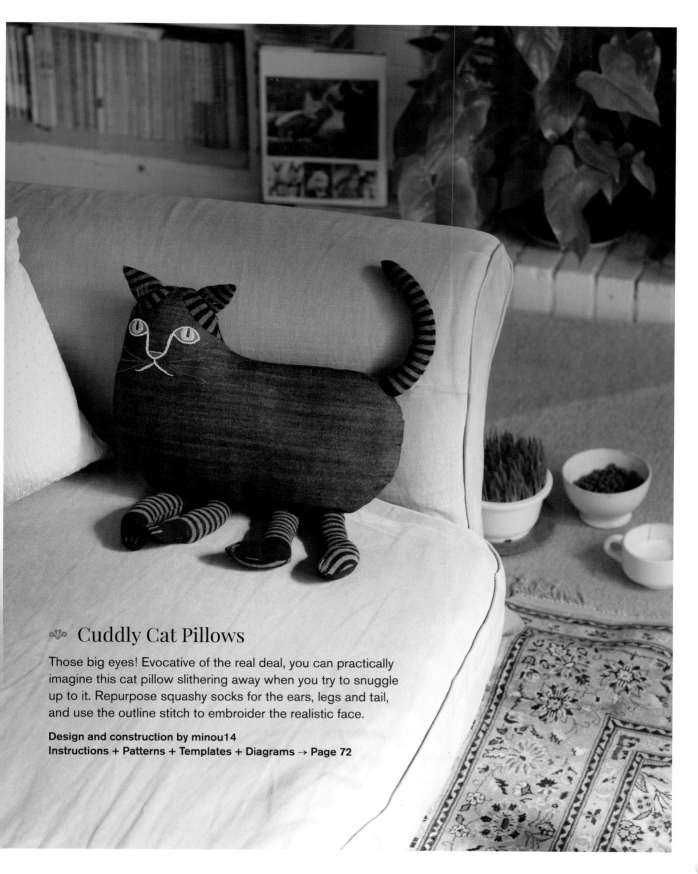

♣ Cuddly Cat Pillows

Those big eyes! Evocative of the real deal, you can practically imagine this cat pillow slithering away when you try to snuggle up to it. Repurpose squashy socks for the ears, legs and tail, and use the outline stitch to embroider the realistic face.

Design and construction by minou14
Instructions + Patterns + Templates + Diagrams → Page 72

31

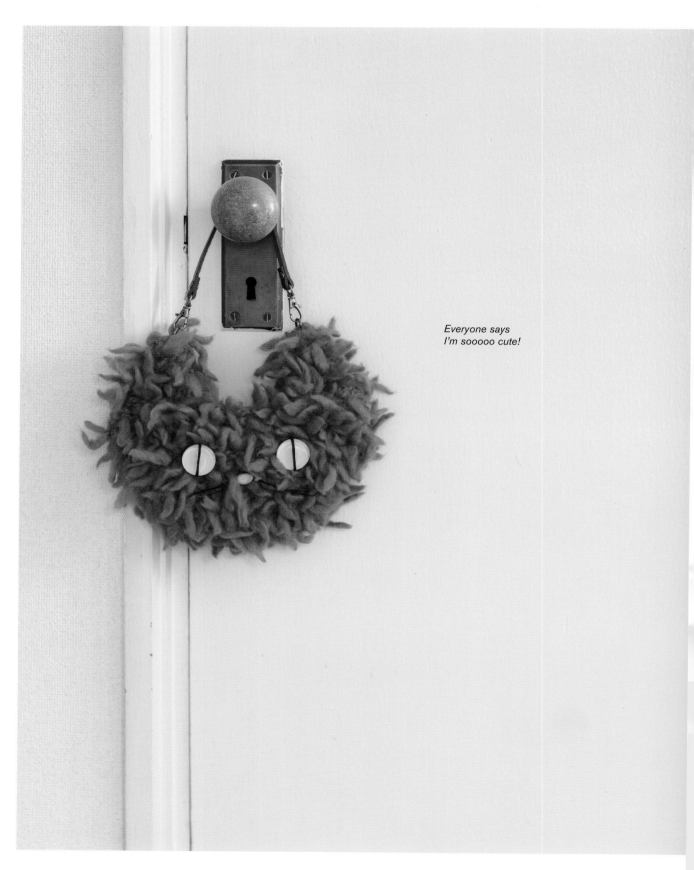

*Everyone says
I'm sooooo cute!*

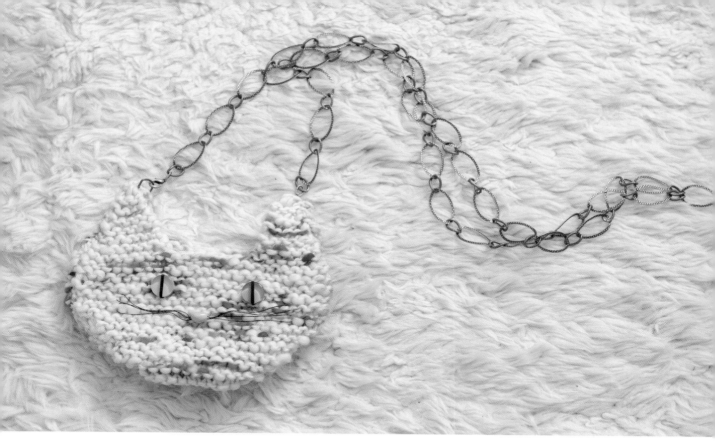

❧ Cat Pouch and Cat Pochette

The long-haired cat pouch is made with fringed yarn. The odd-eyed kitty is made with white variegated dyed yarn. Although constructed in the same way, just altering the yarn completely changes the look and feel. How about trying a whole range of different yarns?

Design and construction by Miyuki Hayashi (pouch) Yumi Oami (pochette)
Instructions → Page 44
Knitting Diagrams → Page 74

Cat Pouch

Cat Pochette

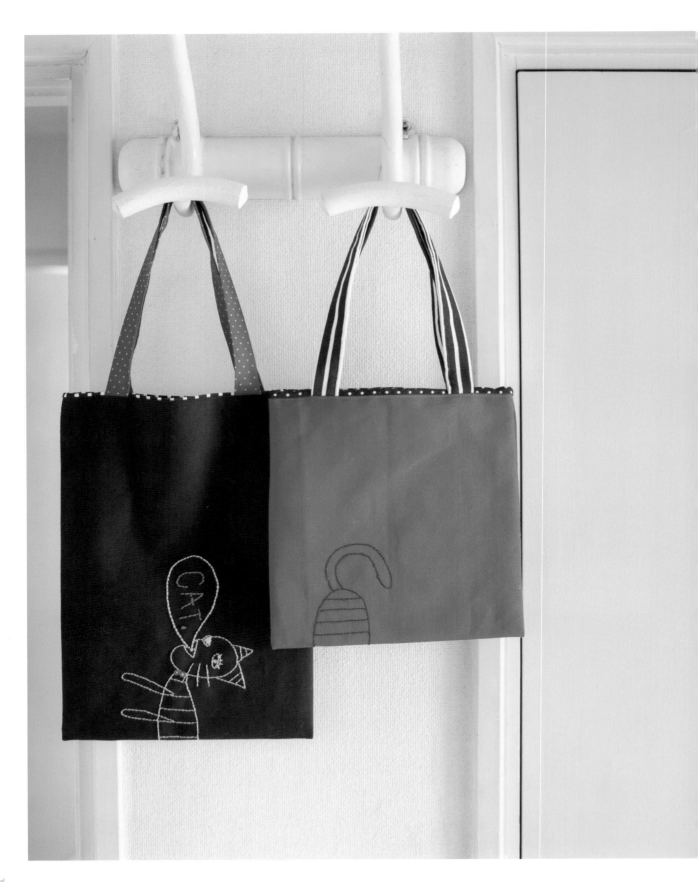

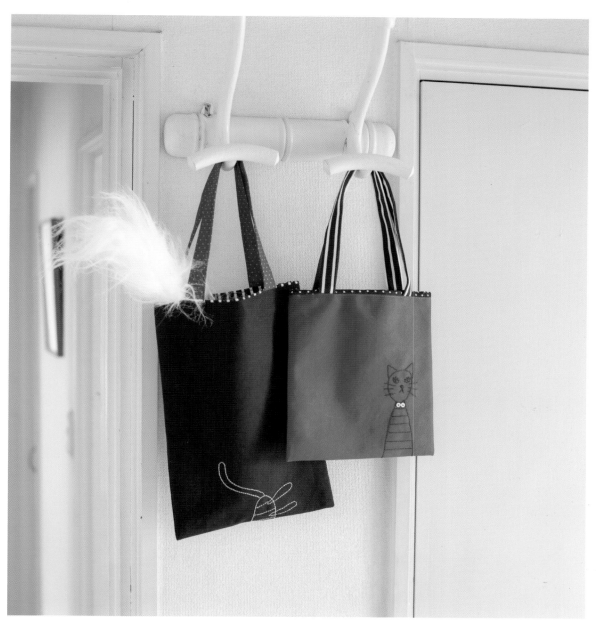

❧ Embroidered Bags

Embroider a tiger cat to extend to both sides of the bag. If you flip the bag to one side, there's a sweet cat face. Flip it over, and a long tail greets you. Head or tail…it might be hard to decide which side to show to the world.

Design and construction by rie
Instructions + Diagrams → Page 76

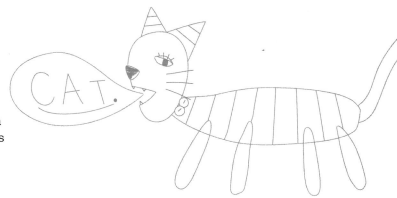

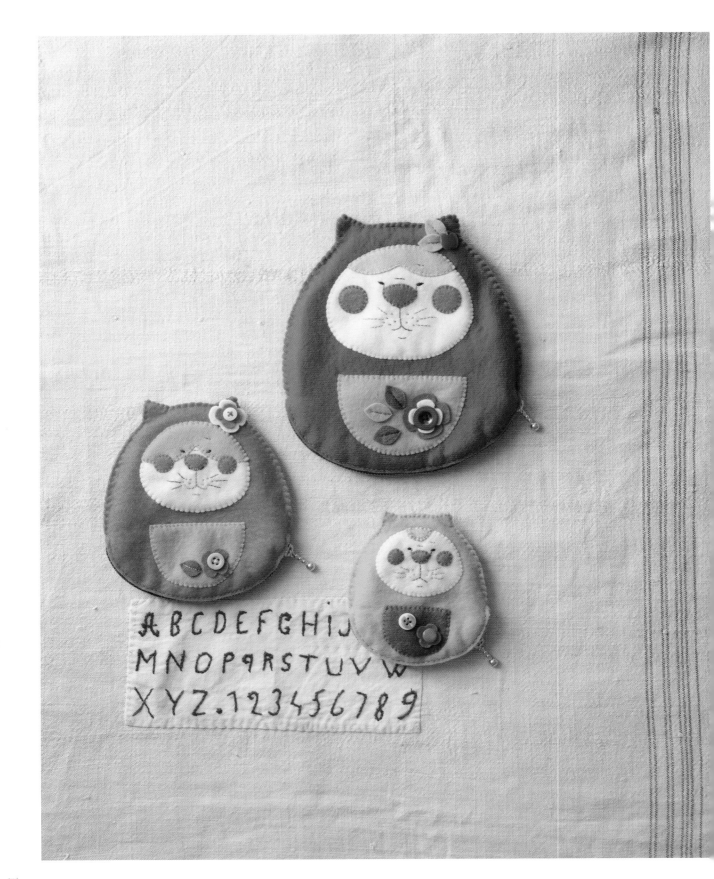

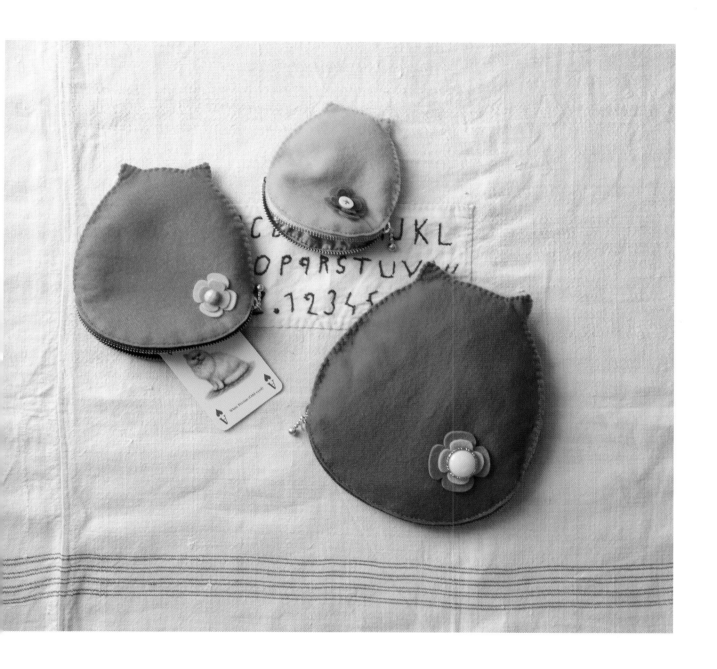

❧ Catryoshka Pouches

Inspired by classic Russian matryoshka dolls, we made
a cat version — nesting pouches. Because they're in a
variety of sizes, these pouches are useful in endless ways.
The largest size easily holds a smart phone.

Design and construction by Marupoleland
Instructions + Patterns + Templates → Page 78

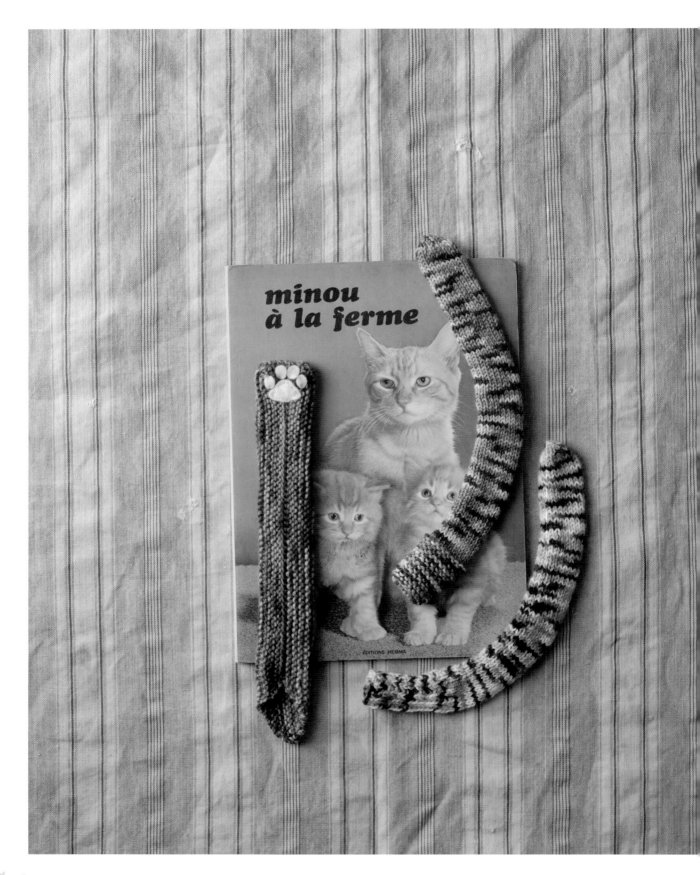

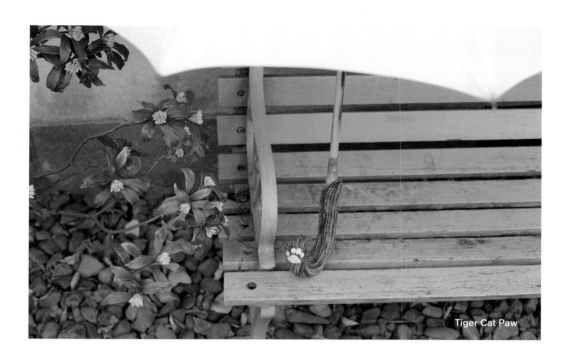

Tiger Cat Paw

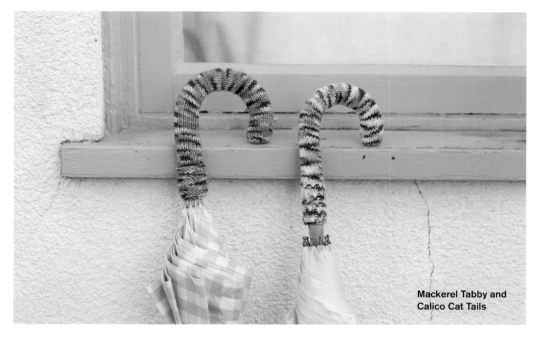

Mackerel Tabby and
Calico Cat Tails

❦ Umbrella Handle Covers

A tiger cat's paw and the tails of a mackerel tabby and calico cat. At first glance, these may not seem like the most utilitarian items, but when rain showers fall, the delight factor will quickly become apparent. These knitted covers make gripping the umbrella handle easier and add personality to what could be a plain rainy-day necessity.

Design and construction by Kanade Isshiki
Instructions + Patterns + Templates + Knitting Diagrams → Page 47, 75

❧ How to make the Mini Mini Pouches on Page 14

Small and cube-shaped, this pouch comes together quite easily by quilting the main and gusset sections separately and then assembling together at the end.

Tips

1

Make the pouch and gusset (2 pieces).

2

Appliqué and embroider face onto pouch. Use two-sided fusible interfacing for extra ease.

3

Assemble pouch and gusset parts with a whip stitch.

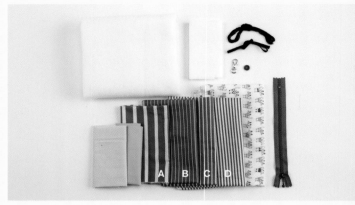

Materials

- ❊ Outer fabric + Tail fabric (stripes)… A: 3½ x 3½ in (9 x 9 cm) B: 7⅞ x 3½ in (20 x 9 cm) C: 10¼ x 10¼ in (26 x 26 cm) D: 8⅝ x 2 in (22 x 5 cm)
- ❊ Lining fabric (print fabric)… 9⅞ x 9⅞ in (25 x 25 cm)
- ❊ Appliqué fabric (light blue, light green)… as needed
- ❊ Zipper 7 in (18 cm) length
- ❊ Lobster claw swivel clasp…1
- ❊ #5 Embroidery thread (black)…as needed
- ❊ Two-sided fusible interfacing
- ❊ Flat cotton cord ¼ in (5 mm) width (black)…enough for a 1⅛ in (3 cm) finished length

✿ Layout

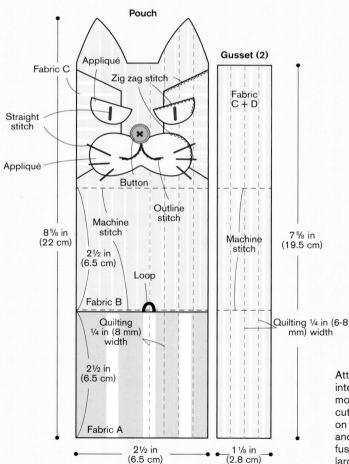

Pouch

Fabric C

Appliqué

Zig zag stitch

Gusset (2)

Fabric C + D

Straight stitch

Appliqué

Button

Outline stitch

Machine stitch

Machine stitch

8⅝ in (22 cm)

7⅝ in (19.5 cm)

2½ in (6.5 cm)

Loop

Fabric B

Quilting ¼ in (6-8 mm) width

Quilting ¼ in (8 mm) width

2½ in (6.5 cm)

Fabric A

2½ in (6.5 cm)

1⅛ in (2.8 cm)

❊ Cutting the fabric and materials

Appliqué fabric

Quilt batting

Attach two-sided fusible interfacing to the eyes and mouth appliqué pieces, then cut using the pattern sheets on page 58. For the pouch and gusset pieces, cut the fusible quilt batting slightly larger, iron onto the pieces, then trim down.

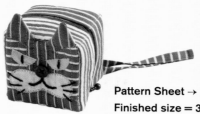

Pattern Sheet → Page 58

Finished size = 3⅜ in (8.5 cm) high x 2½ in (6.5 cm) wide x Gusset 2½ in (6.5 cm)

Two-sided fusible interfacing

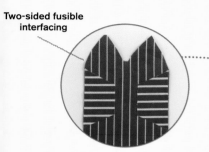

On the outer fabric of the pouch, position the striped appliqué fabric horizontally and instead of sewing, attach using the two-sided fusible interfacing.

Outer fabric

Gusset

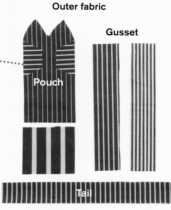

Pouch

Tail

Refer to pattern sheet on page 58 and add ⅜ in (1 cm) seam allowance to each piece. For the outer fabric, cut the 4 types of stripes into the designated pieces.

Lining

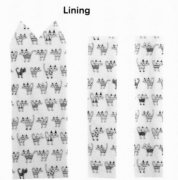

Add ⅜ in (1 cm) seam allowance to the lining as well and cut out the lining print fabric.

※ Piece together the outer fabric pieces

1. Make loop. Cut the cord to 1⅛ in (3 cm), fold in half and baste to the front of the lower section as shown in photo.

2. Sew together the upper and lower sections of the pouch with right sides together.

※ Quilt

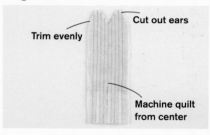

Trim evenly

Cut out ears

Machine quilt from center

1. Cut a piece of two-sided fusible quilt batting to match the pouch, place on the wrong side of the pouch piece and lightly iron on. Don´t iron directly on the fusible batting; rather, overlay pattern or Swedish tracing paper while ironing. Machine quilt.

Trim evenly

Machine quilt from center

2. Repeat step 1 for the gusset pieces: attach quilt batting and machine quilt.

Front side of quilted fabric

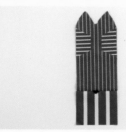

3. Quilt in ¼ in approx. (6-8 mm) intervals

¼ in (8 mm) width

Approx. ¼ in (6-7 mm) width

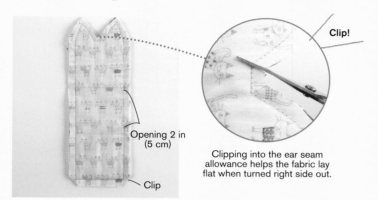

※ Attach lining

Clip!

Clipping into the ear seam allowance helps the fabric lay flat when turned right side out.

Opening 2 in (5 cm)

Clip

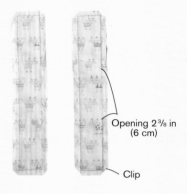

Opening 2⅜ in (6 cm)

Clip

1. With right sides together, sew lining and pouch together, leaving an opening. Trim the seam allowance to about ¼ in (4~5 mm) and clip corners. ∗Trimming the quilt batting seam allowance as close to the seam as possible ensures better results.

2. Repeat step 1 for the gussets and gusset linings. Sew with right sides together, leaving an opening. Trim and clip seam allowance and corners.

※ Turn right side out, appliqué and embroider

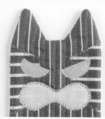

Machine stitch

1. Turn right side out from the opening, press firmly – including the lining – to shape. Slip stitch opening closed.

2. Iron on the eyes and mouth area appliqué pieces, then zig zag stitch around the edges.

3. Machine stitch as shown.

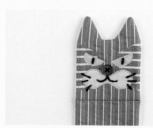

4. Embroider the eyes and whiskers with a straight stitch and the mouth with an outline stitch (2 strands of embroidery thread). Sew on a button for the nose.

※ Attach zipper to gusset

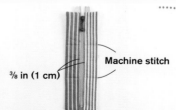

⅜ in (1 cm)

Machine stitch

Sew zipper tape from wrong side with half back stitch

1. Machine stitch the gusset as you did for the pouch in step 3 above. Place the zipper as shown, lining up the centers. Sew along the zipper tape from the wrong side.

Sew the zipper tape from the wrong side of the gusset using a half back stitch. Do not sew all the way through to the outer fabric and stitch the zipper to the lining.

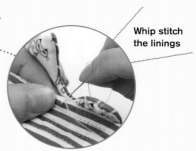

✖ Sew pouch and gussets together

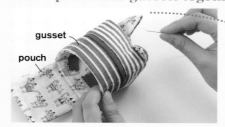

gusset

pouch

1. Assemble as shown in the photo and sew from the bottom with a whip stitch (stitch the ear section to the lining).

Whip stitch the linings

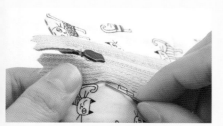

To whip stitch, it's helpful to sew the linings together from the front side.

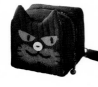

2. Stitch zipper tape ends to lining on wrong side.

✖ Make the tail

³⁄₈ in (1 cm)

1. Fold the fabric for the tail into ³⁄₈ in (1 cm) quarters, then sew along each long side.

¹⁄₈ in (3 mm)

2. Insert into the lobster claw clasp, fold in half, then sew ends together about ¹⁄₈ in (3 mm) from the tip.

¼ in (5 mm)

3. Fold over tip and sew ¼ in (5 mm) from edge. Attach clasp to the pouch loop.

Variations

Changing the fabric and appliqué produces a variety of kitty pouches.

Black fabric → Even the tail is all black.

The blue eyes are the charm point.

Light brown + dark brown print fabric → Siamese cat

Adding dark brown print fabric to a light brown body will create the distinctive Siamese coloring.

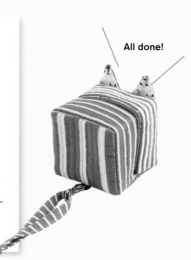

All done!

2 types of brown polka dots + plain natural fabric → Hachiware

A playful combination of two types of polka dot fabrics create the inverted "V" fur markings that Hachiware cats are known for.

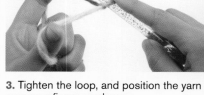

❧ How to make the Cat Pochette on Page 33

A quick and easy garter stitch. Made entirely out of knit stitches, the front and back look identical.

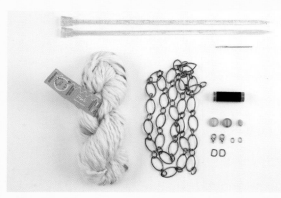

Knitting Diagram → Page 74

Finished size = 7½ x 8¼ in (19 x 21 cm) (excluding the handle)

Materials

✖ Extra thick variegated yarn 1 skein approx.
✖ 10 yards = 3.5oz (9.5m = 100g)
✖ Handsewing thread (black)…as needed
✖ D-ring…2
✖ Chain…47¼ in (120 cm)
✖ Flat 15 mm diameter elliptical beads (blue, yellow)…1 each
✖ Barrel-shaped 7mm bead (pink)…1
✖ Knitting needles jumbo US 11 (Japanese 8), binding needle

Tips

1

For the row on the wrong side, use the knit stitch.

2

For the face section, yarn over the first stitch, then knit through the back of loop for the next row.

3

For ears, knit two together to decrease.

✖ Cast on (first row)

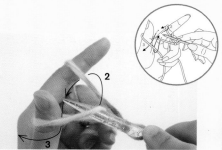

1. Make a loop, and pull the shorter end of the yarn through.

2. Insert one of the knitting needles through the loop (normally two needles would be inserted, but this will be the bottom of the bag so we will use one needle to avoid loose stitches).

3. Tighten the loop, and position the yarn over your finger as shown.

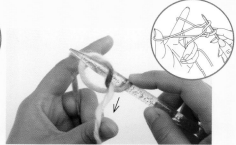

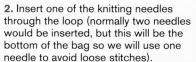

4. As shown in the illustration above, follow the first arrow to insert the needle in front of your thumb, then follow arrows 2 and 3 and move the needle accordingly.

5. The illustration shows the second cast-on stitch in progress. You will temporarily remove your thumb, then reinsert it as shown in the photo to pull the yarn and tighten the stitch.

6. Repeat steps 3-5 and cast on 10 stitches.

□ = ‖

※ Second row (knitting a row on the wrong side)

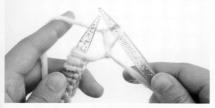

Switch needle with stitches to left hand and start knitting.

※ Yarn over ⊙

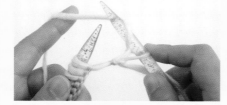

1. Bring yarn over from the right needle, loop it around needle.

2. Knit the next stitch regularly.

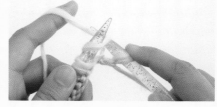

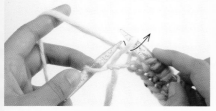

3. Continue knitting, do a yarn over 1 stitch before the end, knit the last stitch and the second row is complete.

‖ = ‖

※ Third row (Knitting a row on the right side)

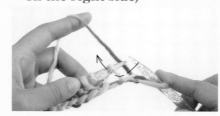

1. Knit the stitch.

※ Knit through the back of the loop on the right side ♀

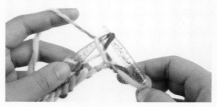

2. Insert needle in the stitch created from the yarn over in the direction of the arrow shown, and pull yarn through. You have now knit through the back of the loop.

※ Knit through the back of the loop on the left side ♀

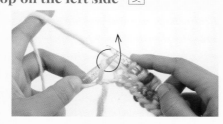

1. Reverse the direction of the twist. Instead of knitting the yarn over, transfer it to the right needle, then insert left needle in the direction of the arrow shown and move the stitch back.

2. Insert the right needle in the direction of the arrow when the yarn over stitch turns.

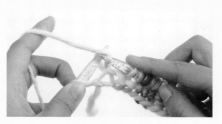

3. Knit. You have not knit through the back of the loop from the left side.

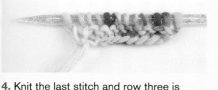

4. Knit the last stitch and row three is complete (each end of the row includes a knit through the back of the loop). Repeat the yarn over and knitting through the back of the loop to increase stitches up to row 17.

※ Knit the ears

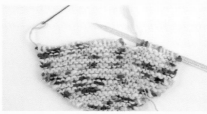

Continue knitting to row 26 without increasing or decreasing. For row 27, knit 9 stitches, then thread a different colored yarn through the remaining 17 stitches (we will return to these stitches later).

※ Left ear – upper right knit two together ⋋

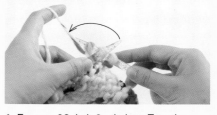

1. For row 28, knit 9 stitches. Turn the knitting over for row 29. Knit first stitch. Slip the second stitch onto the right needle without knitting. Knit the next three stitches. Pull the yarn over stitch over a knitted stitch.

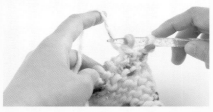

2. Upper right knit two together complete.

3. 40th row after decreasing stitches. Knitting has been turned over.

1. For the 41st row, slip the first stitch on to the right needle without knitting. Insert needle from the left of the two remaining stitches, then knit together.

2. Pull the yarn over stitch from the right needle over the knitted stitch.

3. Upper right knit three together complete. Leave a yarn tail of about 5⁷⁄₈ in (15 cm) and cut. Pull through the remaining stitch.

※ Bind off ●

Binding off one stitch

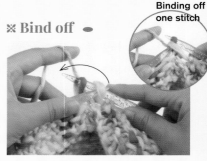

1. Insert needle in the stitches set aside with the different colored yarn. Knit the first stitch and start binding off.

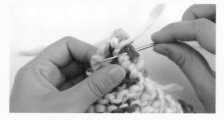

2. Repeat step 1 and bind off the 8 stitches between the ears. There should be 9 stitches remaining for the right ear.

※ Right ear ~ Upper left knit together ⊼

Knit up to row 29 plus three stitches from the left. Insert the needle from the left side and knit two together. Upper left knit two together complete.

※ Upper left knit three together ⊼

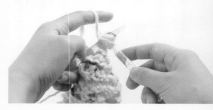

For the 41st row, insert the needle from the left side and knit three stitches together. Upper left knit three together complete. As you did with the left ear, pull the yarn through the last stitch and tighten.

※ Whip stitch

1. Knit the other side of the cat pochette using the same method as above.

2. Whip stitch. Leaving the pochette opening, whip stitch all around to make the bag.

※ Embroider face

Sew on buttons for eyes and nose with black handsewing thread. Embroider whiskers (use 1 strand).

❧ How to make the Umbrella Handle Cover (Tiger Cat Paw) on Page 38

Made using the garter stitch just like the Cat Pochette. We'll incorporate stitch increasing methods including yarn over and creating two stitches from one.

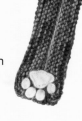

Knitting Diagram → Page 75
Finished size = 9½ in (24 cm)
long 1⅜ in (3.5 cm) wide

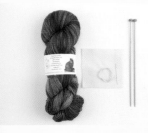

Materials

※ Fine variegated brown yarn 3.5 oz (10 g)
※ Felt (pink)...as needed
※ #25 Embroidery thread (light pink)...as needed
※ Knitting needles size 2
※ Embroidery needle

Paw Pads Actual Size Template

※ Second row ~ Increase stitches by knitting two stitches from one

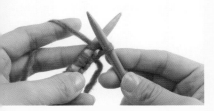

1. Refer to the cast-on steps for the Cat Pochette (page 44) and cast on 52 stitches (first row). For the second row, insert the right needle into the first stitch and pull yarn through.

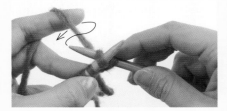

2. Without removing the stitch from the left needle, insert the right needle from the other side of the stitch and pull yarn through in the direction of the arrow shown.

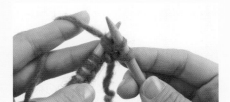

3. Yarn pulled through.

4. Slip stitch off of left needle. Second stitch knitted. Increase the stitches on left edge the same way.

※ Knit up to 20 rows

From the fourth row, start doing the yarn over and knitting through the back of the loop combination (see page 45) up to the 20 row.

※ Row 21~Complete knitting

From the 21st row, knit two together on each end (see pages 45–46).

※ Sew together

1. Bind off ends. Fold in half with right sides together and whip stitch in place.

2. Fold up one triangular end, and whip stitch in place.

※ Appliqué

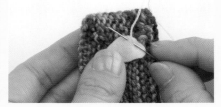

Cut out pink felt for the paw pads and using pink embroidery thread, stitch onto handle cover with a half back stitch.

Neko
The Creatives and Their Cats

Behind every lovely project is an actual, adorable cat. What kind of cats are the trusty assistants and sidekicks for these creative folks?

Yumi Oami + Tabi and Peanuts
Knit designer/writer. [By day, she works at "Keito" shop, and at home she's gently guarded by Tabi and Peanuts while she knits. The black and white cats are siblings.]

Mico Ogura + Nicola
Illustrator. [She never comes when I call and she's reserved, but when I'm feeling down she always comes to soothe me. Thank you for understanding me more than anyone else, Nicola.]

Miyuki Hayashi + Neighbor cat
Knit designer/writer. [Handmade projects and kitties have been near and dear to me since I was a little girl. Although I don't have my own pet right now, the neighbor cats come to comfort me all the time!]

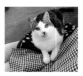

Chizuko Kojima + "Fuku"
Quilt designer/writer. [I rescued a kitten that wandered into my yard and named her "Fuku," which means fortune. Fortune came for her and she brought fortune into my home too!]

minou14 + Kuu & Coco
Cat Accessory designer/writer. [The sibling kitties get along so well with each other! They're like mischievous toddlers and are too adorable for words!] http://ameblo.jp/0914miko/

Naoko Suzuki + Kaasan
Quilt designer/writer. Printmaker. [Kaasan has been my inspiration and project model for 10 years!]

Kyoko Maruoka
Cross Stitch designer/writer. [I don't have a pet cat, but the felines from storybooks have always fed my imagination] http://www008.upp.so-net.ne.jp/ge

Yoko Kobayashi + Akane
Quilt designer/writer. [This year she turns 17. She's a scaredy-cat and a homebody, but she's got a lovely personality and sharp mind. She's a valuable member of the family.]

Hitomi Hanaoka + Amane
Quilt designer/writer. [Almost 18-years-old. Amane is shy and somewhat needy. She loves to gaze outdoors and I often find her in conversation with the birds in the yard] http://quilt-andante.com/

rie
Designer/writer of handmade projects. [Since I have a dog-like face, I am perpetually inspired by the cat face. I want to make a cat doll and I dream of owning my own kitty one day.]

Kanade Isshiki + She-chan
Hand-knitting designer/writer. [Whenever I'm cooking, she suddenly appears behind me. I live with She-chan (8-year-old girl cat) and over a hundred colors of yarn.]

Marupoleland + Tamaco and Hatosuke
Cat artist. [Tamaco is a rust-colored Calico and she's tough as nails. Hatosuke, the black and white one, is eternally hungry, but he's the gentlest boy. They're both rescues.]
twitter:@marupoleland
instagram:marupoleland

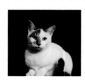

nekogao + Mimi and Chicchi
Fabric accessory designer/writer. [Mimi is a refined beauty. Chicchi is a prankster and is always getting in trouble with Mimi [lol].]
http://nekogaojaco.blog.fc2.com/https://Instagram.com/nekogaoneko/

General Guidelines

Unless specified otherwise, all dimensions provided are for finished sizes. In some cases diagrams, patterns and templates may require seam allowances.

Project finished sizes (length x width, height, etc.) are based on the samples in the book. Depending on construction methods, sizes may vary slightly.

Measurements are given in both imperials and metrics. The metric measurements are precise, while the imperials are approximate.

st. = stitch, the circled numbers specify the number of embroidery strands to use.

See page 57 for embroidery techniques.

Cross Stitch Buttons on Pages 6-7 Finished size = 1⅝ in (4 cm) diameter

Materials

#25 Embroidery thread…as needed of each color; Use 2 strands for all DMC embroidery thread; unless otherwise specified use cross stitch. Refer to color chart below, Fabric (olive)…4¾ x 4¾ in (12 x 12 cm), Covered button kit 1⅝ in (4 cm) diameter…1

For how to make a covered button and other supplies, see pages 18-19
See page 18 for White Cat +Blue and Brown Cat + Black

Tip

The black cat on the larger button and the cats on the smaller button (white, Mackerel tabby, brown tiger) use the same diagram with different color schemes. You could simply change the colors and/or stitch the smaller motifs on the large button.

Embroidery Diagram

Black Cat + Yellow Green
Straight stitch (959)

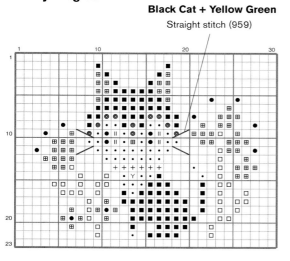

Small Buttons (page 18-19) Diagram

White Cat + Blue
Fabric

Brown Tiger Cat + Black
Fabric

Straight stitch (436) Straight stitch (712)

Cross stitch color scheme

■ 310 Black	✕ 436 Brown	● 823 Navy blue	
⊞ 3706 Peach	Y 3852 Mustard yellow	‖ 959 Aqua	◎ 924 Dark Gray
✳ 3790 Burnt brown	• 712 Cream	☐ 3810 Blue	+ 321 Red

❦ Embroidered Brooches on Page 4-5 Finished size = 2¼ x 2⅜ in (5.8 x 6 cm)

Materials (for one)

Front fabric (linen, natural organic cotton, etc.)…4 x 4 in (10 x 10 cm), Back fabric (dark blue)…4 x 4 in (10 x 10 cm), #25 Embroidery thread (indigo)…as needed, Cotton batting…as needed, Pin back (silver) 1 in (2.5 cm)…1

Tips

• Use the diagram on the lower right of page 4. Play around with the expression as you free stitch by changing the angle of the mouth or size and position of the eyes. Consider using buttons for eyes like the brooch on page 5.
• Modify the running stitch markings to your liking.

How to make

1. Transfer the cat template onto the front fabric and embroider (see page 57 for embroidery techniques)

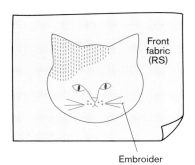

Front fabric (RS)

Embroider

2. Add seam allowance to front and back fabrics, then cut.

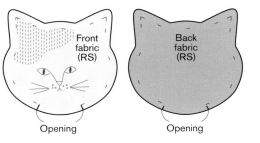

Front fabric (RS)

Back fabric (RS)

Opening Opening

3. Sew front and back fabrics together with right sides facing, leaving an opening. Turn right side out from the opening.

Back fabric (RS)

Sew

Front fabric (WS)

Opening

4. Fill with cotton batting and stitch opening closed

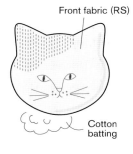

Front fabric (RS)

Cotton batting

5. Attach pin back to the back side.

Pin back

Actual Size Template
Add ¼ in (6 mm) seam allowance before cutting

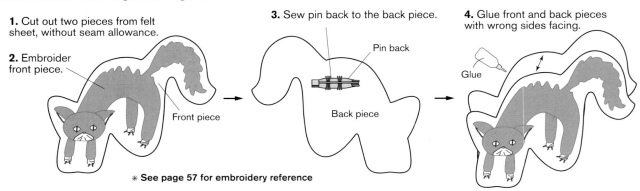

Running Stitch ②

Satin Stitch ②

Outline Stitch ②

Straight Stitch ②

Straight Stitch ②

Opening

How to make the Badges on Page 51

1. Cut out two pieces from felt sheet, without seam allowance.

2. Embroider front piece.

Front piece

3. Sew pin back to the back piece.

Pin back

Back piece

4. Glue front and back pieces with wrong sides facing.

Glue

*** See page 57 for embroidery reference**

Perfectly Embroidered Badges on Pages 8–9

Finished size = **Surprised Hachiware** approximately 2½ x 3⅛ in (6.5 x 8 cm), **Bibliophile Cat** approximately 2 x 2 in (5 x 5 cm), **White Odd-eyed Cat** approximately 1⅝ x 2½ in (4 x 6.5 cm), **Chubby Cat** approximately 2⅜ x 2⅜ in (6 x 6 cm)

Materials

Surprised Hachiware main fabric (thick felt · off white)…7⅞ x 4 in (20 x 10 cm), Acrylic mohair (black · white)…as needed, #25 Embroidery thread (lemon yellow · black · pink)…as needed

Bibliophile Cat main fabric (thick felt · blue)…4¾ x 2¾ in (12 x 7 cm), Acrylic mohair (black)…as needed, #25 Embroidery thread (lemon yellow · pink beige · black · blue · yellow · aqua)…as needed

White Odd-eyed Cat main fabric (thick felt · off white)…5½ x 3⅛ in (14 x 8 cm), Acrylic mohair (white)…as needed, #25 Embroidery thread (aqua · black · pink · yellow)…as needed

Chubby Cat main fabric (thick felt · gray)…5⅞ x 4 in (15 x 10 cm), Felt (white), Acrylic mohair (light gray · white)…as needed, #25 Embroidery thread (gray · black · white)…as needed, Pin back (silver) 1 in (2.5 cm)…4

Other tools and supplies: craft glue

Tip

Rub the mohair a little after embroidering to let the hairs stand up to add texture and dimension.

✻ See page 50 for how to make the badge

Actual Size Template
Cut main felt pieces without seam allowance
Unless otherwise specified, use #25 embroidery thread
⟶ = Indicates direction of satin stitch

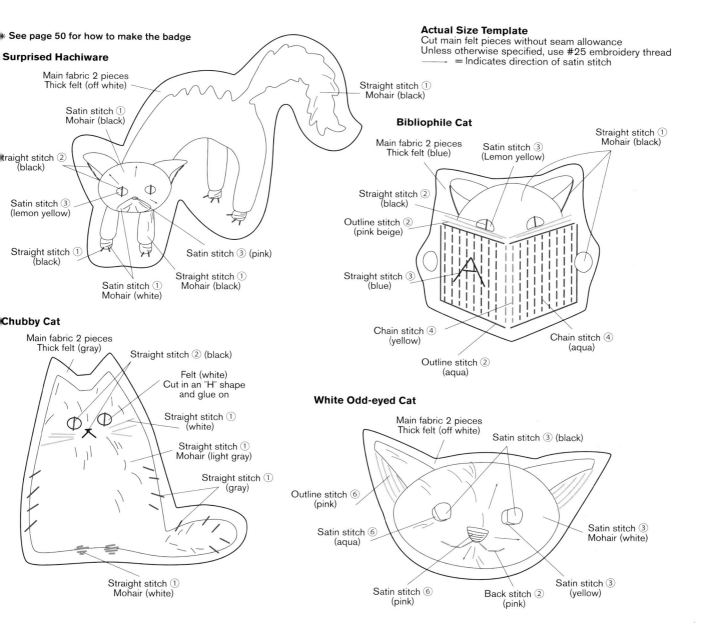

Surprised Hachiware

Main fabric 2 pieces
Thick felt (off white)

Satin stitch ①
Mohair (black)

Straight stitch ②
(black)

Satin stitch ③
(lemon yellow)

Straight stitch ①
(black)

Satin stitch ①
Mohair (white)

Straight stitch ①
Mohair (black)

Satin stitch ③ (pink)

Straight stitch ①
Mohair (black)

Bibliophile Cat

Main fabric 2 pieces
Thick felt (blue)

Satin stitch ③
(Lemon yellow)

Straight stitch ①
Mohair (black)

Straight stitch ②
(black)

Outline stitch ②
(pink beige)

Straight stitch ③
(blue)

Chain stitch ④
(yellow)

Chain stitch ④
(aqua)

Outline stitch ②
(aqua)

Chubby Cat

Main fabric 2 pieces
Thick felt (gray)

Straight stitch ② (black)

Felt (white)
Cut in an "H" shape
and glue on

Straight stitch ①
(white)

Straight stitch ①
Mohair (light gray)

Straight stitch ①
(gray)

Straight stitch ①
Mohair (white)

White Odd-eyed Cat

Main fabric 2 pieces
Thick felt (off white)

Satin stitch ③ (black)

Outline stitch ⑥
(pink)

Satin stitch ⑥
(aqua)

Satin stitch ③
Mohair (white)

Satin stitch ⑥
(pink)

Back stitch ②
(pink)

Satin stitch ③
(yellow)

51

Shrink Plastic Pins and Earrings on Pages 10-11

Finished size = Pins - **Mackerel Tabby + White** approximately 1 5/8 in (4 cm) diameter; **Others** approximately 1 3/8 in (3.5 cm) diameter; **Earrings** approximately 3/4 in (2 cm) diameter each

Materials

Yellow Kitty See page 20 for reference

Pin 0.2mm-thick Shrink Plastic 4 x 4 (10 x 10 cm), Dermatograph pencil (black), Acrylic paint (various colors), Thick felt…2 x 2 in (5 x 5 cm), Faux leather (navy blue)…2 x 2 in (5 x 5 cm), Plastic beads 3 mm (in coordinating colors)…40, Pin back…1, #25 Embroidery thread (white)… as needed (for the Mackerel Tabby only)

Earrings 0.3mm-thick Shrink Plastic 4 x 4 in (10 x 10 cm), Dermatograph pencil (black), Acrylic paint (various colors), Faux leather (black)…1 5/8 x 3 1/8 in (4 x 8 cm), Earring posts and backs…1 set

Other tools and supplies

Fine grit sandpaper, aluminum foil, brush (small), small scissors, woodworking glue, all purpose glue, Fray Check or similar, masking tape, toaster oven or conventional oven, awl (for earrings only)

Tips

• For the earrings, the 0.2mm thickness shrink plastic is fine, but we recommend the 0.3mm

• Immediately after baking, you can create a button-like groove by pressing a pen to the back of the earrings.

• The plastic will shrink down to 1/3 to 1/2 of its original size when baked.

How to make the pin

1. See pages 20-21 for reference on how to make the plastic piece. Temporarily secure onto thick felt with masking tape.

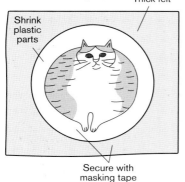

Thick felt
Shrink plastic parts
Secure with masking tape

2. Embroider and cut out.

✳ Only embroider the **Mackerel Tabby + White**

Chain stitch ② (white)

Cut

3. Cut the faux leather to match the size in step 2. Sew the pin back.

Pin back

Faux leather

4. Attach 2 and 3 with woodworking glue.

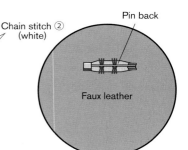

Shrink plastic parts
Woodworking glue
Faux leather

5. Once dry, stitch all around.

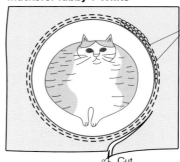

Stitch

(WS)

6. Glue the shrink plastic part down and attach beads (see page 57 for embroidery techniques).

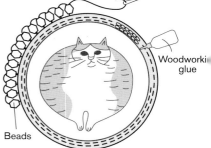

Woodworking glue
Beads

✳ Attach the **Mackerel Tabby + white** with a brick stitch; for the other pins, use a back stitch and blanket stitch.

How to make Earrings

1. In the center of the faux leather, use a tool like an awl to punch a hole for the earring post.

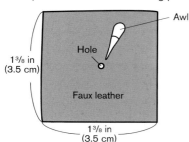

Awl
Hole
1 3/8 in (3.5 cm)
Faux leather
1 3/8 in (3.5 cm)

2. Refer to pages 20-21 to make the shrink plastic parts. Attach the faux leather and earring posts and back with all purpose glue.

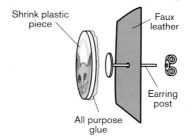

Shrink plastic piece
Faux leather
Earring post
All purpose glue

3. When thoroughly dry, trim around the edges and apply Fray Check.

Fray Check

4. Make two of the same.

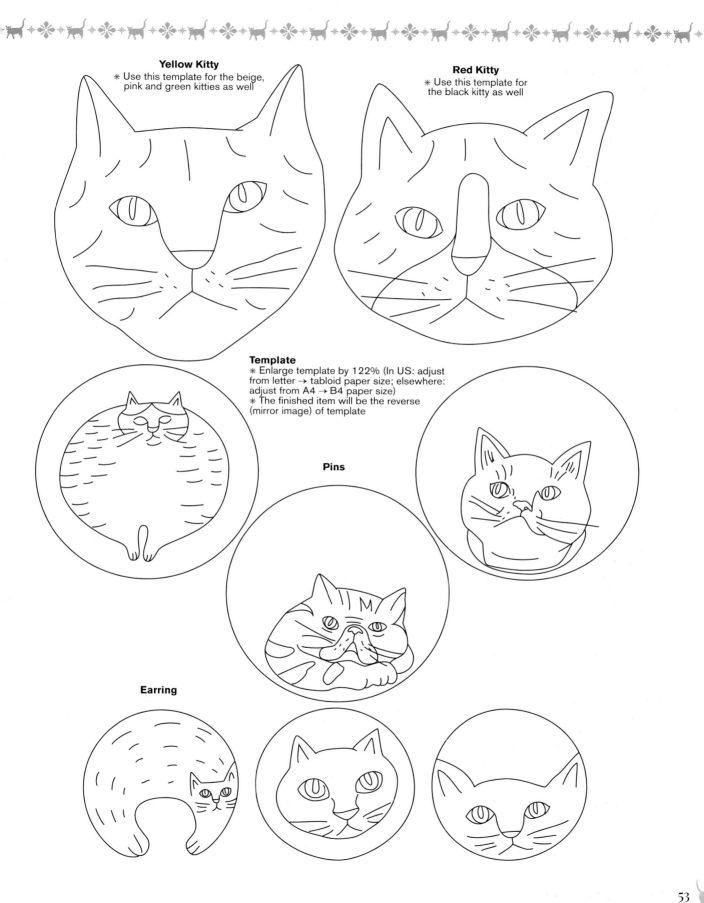

Yellow Kitty
∗ Use this template for the beige, pink and green kitties as well

Red Kitty
∗ Use this template for the black kitty as well

Template
∗ Enlarge template by 122% (In US: adjust from letter → tabloid paper size; elsewhere: adjust from A4 → B4 paper size)
∗ The finished item will be the reverse (mirror image) of template

Pins

Earring

❧ Appliqué Coin Purses on Pages 12–13 For finished sizes see page 55

Materials

Peeking Cat main fabric A…4¾ x 9½ in (12 x 24 cm), Main fabric B…1⅝ x 4¾ in (4 x 12 cm), Lining fabric…4¾ x 9½ in (12 x 24 cm), Appliqué fabric A (linen cotton blend)…2⅜ x 3½ in (6 x 9 cm), Appliqué fabric B (black)…2 x 2⅜ in (5 x 6 cm), Fusible quilt batting…4⅜ x 9 in (11 x 23 cm), Glue-in metal purse frame 1⅝ x 3 in (4 x 7.5 cm)…1

Facing Forward + Polka Dots main fabric…4¾ x 11¾ in (12 x 30 cm), Lining fabric…4¾ x 11¾ in (12 x 30 cm), Appliqué fabric A (linen cotton blend)…3½ x 3½ in (9 x 9 cm), Appliqué fabric B (black)…3⅛ x 2¾ in (8 x 7 cm), Fusible quilt batting…4⅜ x 11 in (11 x 28 cm), Glue-in metal purse frame 2 x 4 in (5 x 10 cm)…1

Facing Sideways + Neutral main fabric…4⅜ x 9⅞ in (11 x 25 cm), Lining fabric…4⅜ x 9⅞ in (11 x 25 cm), Appliqué B fabric (black)…3⅛ x 2¾ in (8 x 7 cm), Fusible quilt batting…4 x 8⅝ in (10 x 22 cm), Glue-in metal purse frame 1⅝ x 3⅛ in (4 x 8 cm)…1

Facing Sideways + Purple main fabric…4¾ x 11¾ in (12 x 30 cm), Lining fabric…4¾ x 11¾ in (12 x 30 cm), Appliqué fabric A (linen cotton blend)…3½ x 4 in (9 x 10 cm), Appliqué B fabric (black)…3½ x 2¾ in (9 x 7 cm), Fusible quilt batting…4⅜ x 11 in (11 x 28 cm), Glue-in kiss lock clasp purse frame (purple) 2 x 4 in (5 x 10 cm)…1

Facing Front + Blue main fabric…4⅜ x 10¼ in (11 x 26 cm), Lining fabric…4⅜ x 10¼ in (11 x 26 cm), Appliqué fabric A (linen cotton blend)…3⅛ x 3⅛ in (8 x 8 cm), Appliqué B fabric (black)…2¾ x 2⅜ in (7 x 6 cm), Fusible quilt batting…4 x 9½ in (10 x 24 cm), Glue-in metal purse frame 1¾ x 3⅛ in (4.5 x 8 cm)…1

Facing Sideways + Yellow Green main fabric…4⅛ x 10⅝ in (10.5 x 27 cm), Lining fabric…4⅛ x 10⅝ in (10.5 x 27 cm), Appliqué fabric A (linen cotton blend)…3 x 2⅜ in (7.5 x 6 cm), Appliqué B fabric (black)…3½ x 2¾ in (9 x 7 cm), Fusible quilt batting…4 x 10¼ in (10 x 26 cm), Glue-in kiss lock clasp purse frame (stripe) 1⅝ x 3⅛ in (4 x 8 cm)…1, #25 Embroidery thread…as needed

Tools and other supplies

Chaco or other transfer paper, craft glue, awl, press cloth, pliers, plain raffia string/ribbon (especially helpful if a thin fabric is being used)

Tips

• The purse frame size is height x width, not including the kiss lock clasp.
• Depending on the maker, the available sizing of purse frames may differ
• This appliqué will test your scissors-wielding skills! Use the sharpest pair you have on hand.

How to make

1. Trace the template onto appliqué fabric A and cut without seam allowance.

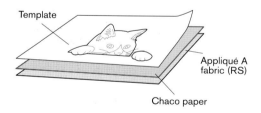

Template / Appliqué A fabric (RS) / Chaco paper

3. Cut main and lining fabrics.

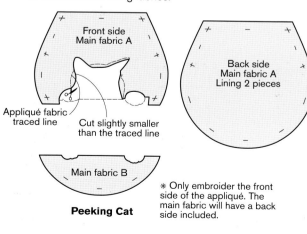

Front side Main fabric A / Back side Main fabric A Lining 2 pieces / Appliqué fabric traced line / Cut slightly smaller than the traced line / Main fabric B / **Peeking Cat**

※ Only embroider the front side of the appliqué. The main fabric will have a back side included.

2. Trace the template for appliqué fabric B and cut out.
※ Use only appliqué B to cut **Facing Sideways + Neutral**

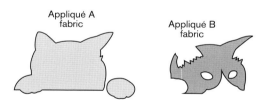

Appliqué A fabric / Appliqué B fabric

4. Temporarily secure main fabrics A, B, appliqué fabrics A, B with glue.

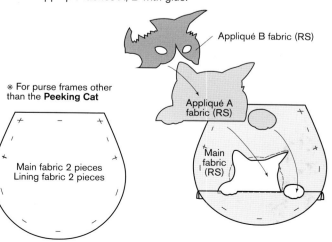

Appliqué B fabric (RS) / Appliqué A fabric (RS) / Main fabric (RS)

※ For purse frames other than the **Peeking Cat**

Main fabric 2 pieces Lining fabric 2 pieces

5. Appliqué and embroider (see page 57 for embroidery techniques)

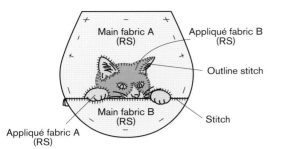

Main fabric A (RS)

Appliqué fabric B (RS)

Outline stitch

Main fabric B (RS)

Stitch

Appliqué fabric A (RS)

6. Attach fusible quilt batting to the wrong side of the front fabric

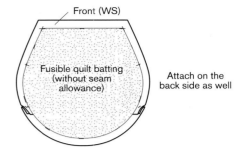

Front (WS)

Fusible quilt batting (without seam allowance)

Attach on the back side as well

7. Sew the front, back and lining with right sides together up to the marking shown

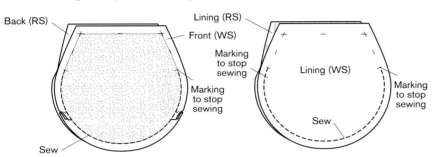

Back (RS)

Lining (RS)

Front (WS)

Marking to stop sewing

Marking to stop sewing

Sew

Lining (WS)

Marking to stop sewing

Sew

8. Turn lining right side out and insert into purse

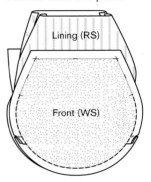

Lining (RS)

Front (WS)

9. Sew purse opening with purse and lining right sides together. Leave an opening to turn right side out.

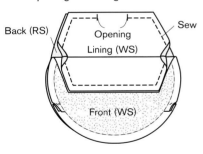

Back (RS)

Sew

Opening

Lining (WS)

Front (WS)

10. Turn right side out from opening and stitch opening closed

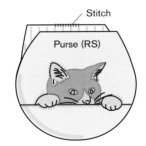

Stitch

Purse (RS)

11. Test the fit by slipping your purse edges into the frame. If the fit is loose, bulk up the purse edges by gluing raffia sting along the lining-side edges. Let dry.

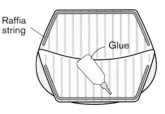

Raffia string

Glue

12. Attach the purse frame. Spread glue evenly in the frame groove, then starting at the center use an awl to push the fabric in.

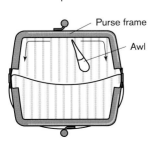

Purse frame

Awl

13. When the glue dries, place a press cloth in four areas of the purse frame, then use pliers to tighten the purse frame where the press cloths are located.

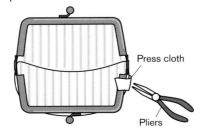

Press cloth

Pliers

Finished Sizes

Peeking Cat	4 1/8 x 4 3/8 in (10.5 x 11 cm)
Facing Sideways + Neutral	3 1/2 x 4 1/8 in (9 x 10.5 cm)
Facing Forward + Polka Dots	4 x 5 1/4 in (10 x 13.5 cm)
Facing Sideways + Purple	4 x 5 1/4 in (10 x 13.5 cm)
Facing Forward + Blue	3 1/2 x 4 1/2 in (9 x 11.5 cm)
Facing Sideways + Yellow Green	3 3/8 x 4 3/4 in (8.5 x 12 cm)

＊ The kiss lock clasp is not included in the measurements

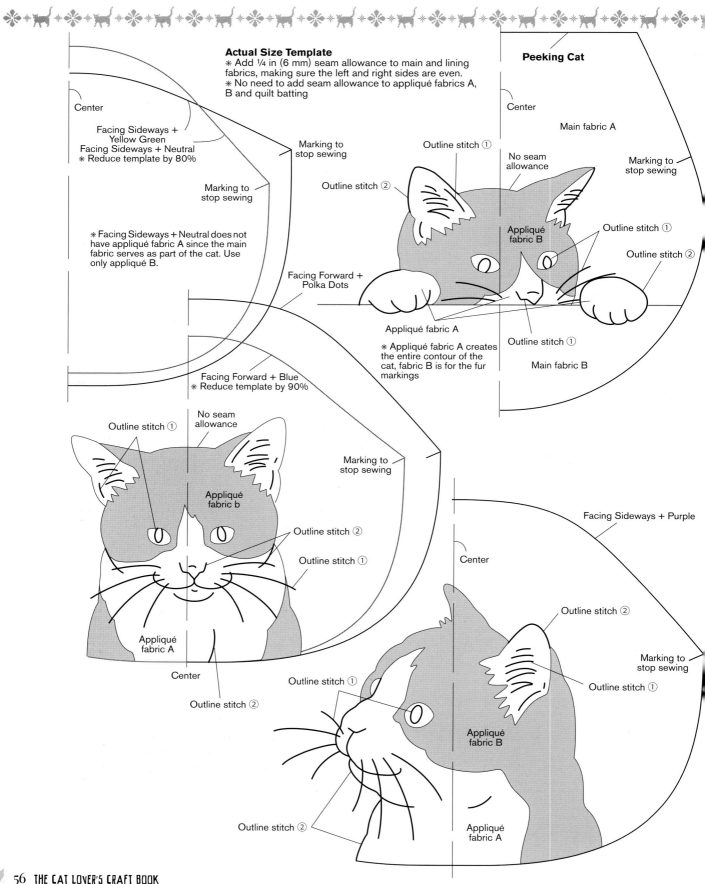

Actual Size Template
* Add ¼ in (6 mm) seam allowance to main and lining fabrics, making sure the left and right sides are even.
* No need to add seam allowance to appliqué fabrics A, B and quilt batting

Peeking Cat

Center

Center

Main fabric A

Facing Sideways +
Yellow Green
Facing Sideways + Neutral
* Reduce template by 80%

Marking to
stop sewing

No seam
allowance

Marking to
stop sewing

Outline stitch ①

Outline stitch ②

Marking to
stop sewing

Appliqué
fabric B

Outline stitch ①

Outline stitch ②

* Facing Sideways + Neutral does not
have appliqué fabric A since the main
fabric serves as part of the cat. Use
only appliqué B.

Facing Forward +
Polka Dots

Appliqué fabric A

Outline stitch ①

* Appliqué fabric A creates
the entire contour of the
cat, fabric B is for the fur
markings

Main fabric B

Facing Forward + Blue
* Reduce template by 90%

No seam
allowance

Outline stitch ①

Marking to
stop sewing

Facing Sideways + Purple

Appliqué
fabric b

Outline stitch ②

Outline stitch ①

Center

Outline stitch ②

Center

Outline stitch ①

Appliqué
fabric B

Marking to
stop sewing

Appliqué
fabric A

Outline stitch ①

Outline stitch ①

Center

Outline stitch ②

Outline stitch ②

Appliqué
fabric A

Straight stitch

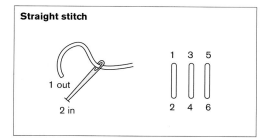

Backstitch

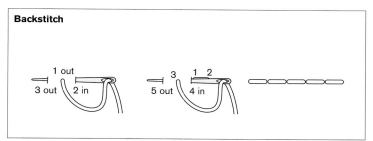

French knot stitch

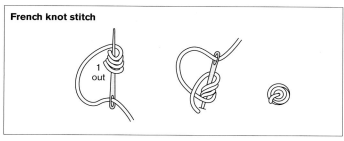

Running stitch

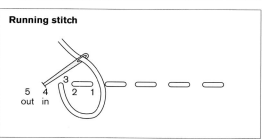

Outline stitch

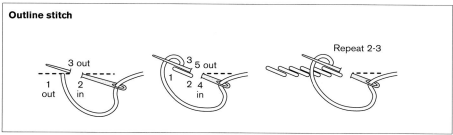

Satin stitch

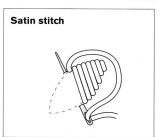

Coaching stitch

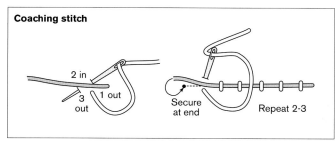

Blanket stitch

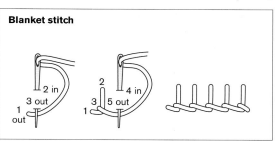

Chain stitch

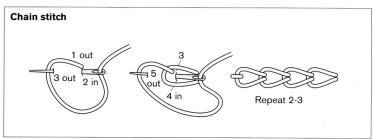

Brick stitch

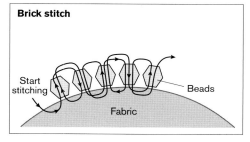

❧ Mini Mini Pouches on Pages 14–15 For finished size see diagrams

Materials

Blue Cat See page 40 for reference

Black Cat outer fabric + Tail fabric (black)…as needed, Lining fabric (brown print)…as needed, Appliqué fabric (blue · metallic)…as needed, Button 3/8 in (1 cm) diameter…1, Zipper 7 in (17 cm) length…1, Lobster claw swivel clasp…1

Siamese Cat outer fabric (light brown print)…as needed, Lining fabric (pink print)…as needed, Appliqué fabric + Tail fabric (blue · brown print)…as needed, Button 1/4 in (8 mm) diameter…1, Zipper 5 1/8 in (13 cm) length…1, Lobster claw swivel clasp…1

Astonished Cat outer fabric + Tail fabric (golden yellow stripes and print · black)…as needed, Lining (white print)…as needed, Appliqué fabric (blue · cream)…as needed, Button 3/8 in (1 cm) diameter…1, Zipper 4 in (10 cm) length…1, Lobster claw swivel clasp for strap (gold)…1, #5 Embroidery thread (black)…as needed, Two-sided fusible quilt batting…as needed, Fusible interfacing, Flat cotton cord 1/4 in (5 mm) width (black)…enough for a finished length of 1 1/8 in (3 cm) (unnecessary for Astonished Cat)

Tips

See pages 40-43 for reference

Blue Cat + Black Cat Layout

* () Numbers within parentheses indicate Black Cat´s measurements
* The lining is a single fabric

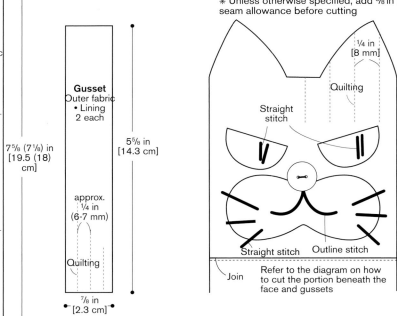

2 3/8 in [6 cm]

2 3/8 in [6 cm]

2 3/8 in [6 cm]

Black Cat

Stitch
Connect (except Black Cat)

Pouch Outer fabric · Lining 1 each

2 1/2 (2 3/8) in [6.5 (6) cm]

Sandwich loop

Stitch

approx. 1/4 in [6-7 mm]

2 1/2 (2 3/8) in [6.5 (6) cm]

Quilting

2 1/2 (2 3/8) in [6.5 (6) cm]

Gusset Outer fabric · Lining 2 each

Stitch

Stitch

approx. 1/4 in (6-7 mm)

Quilting

7 5/8 (7 1/8) in [19.5 (18) cm]

1 1/8 (1) in [2.8 (2.5) cm]

Gusset Outer fabric · Lining 2 each

approx. 1/4 in (6-7 mm)

Quilting

5 5/8 in [14.3 cm]

7/8 in [2.3 cm]

Template

* Enlarge templates by 122% (In US: adjust from letter → tabloid paper size; elsewhere: adjust from A4 → B4 paper size)
* Use 2 strands for all embroidery
* Unless otherwise specified, add 3/8 in (1cm) seam allowance before cutting

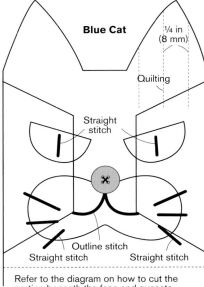

Blue Cat

1/4 in (8 mm)

Quilting

Straight stitch

Outline stitch

Straight stitch Straight stitch

Refer to the diagram on how to cut the portion beneath the face and gussets

* **See page 57 for embroidery techniques**

Black Cat

Template

* Enlarge templates by 122% (In US: adjust from letter → tabloid paper size; elsewhere: adjust from A4 → B4 paper size)
* Use 2 strands for all embroidery
* Unless otherwise specified, add 3/8 in [1 cm] seam allowance before cutting

1/4 in [8 mm]

Quilting

Straight stitch

Straight stitch Outline stitch

Join

Refer to the diagram on how to cut the portion beneath the face and gussets

No seam allowance

Tail
* Same method for all except Astonished Cat

1 5/8 in [4 cm]

8 5/8 in [22 cm]

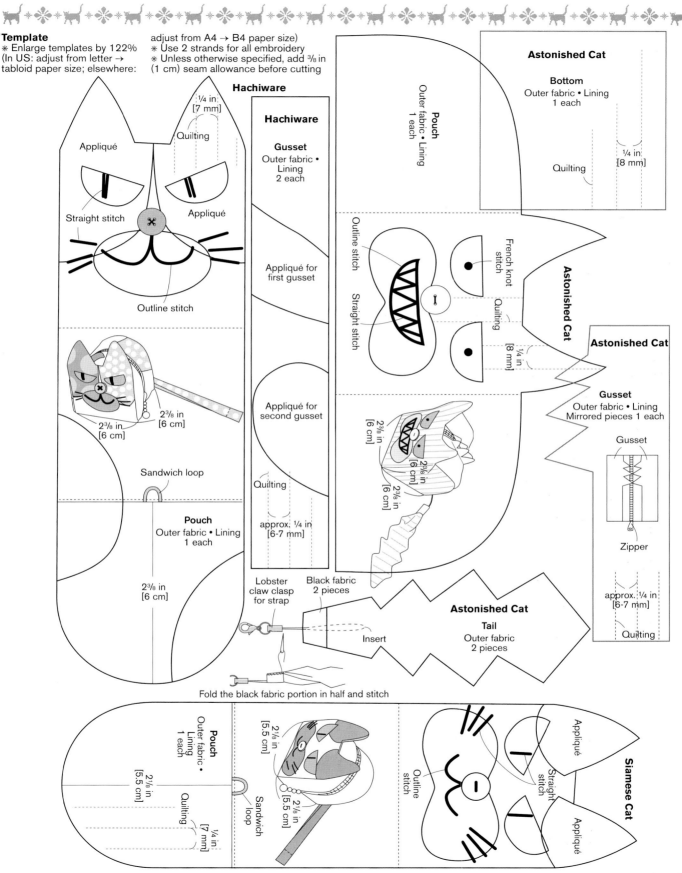

Template

※ Enlarge templates by 122%
(In US: adjust from letter →
tabloid paper size; elsewhere:
adjust from A4 → B4 paper size)
※ Use 2 strands for all embroidery
※ Unless otherwise specified, add ³/₈ in
(1 cm) seam allowance before cutting

Hachiware

Appliqué

¹/₄ in
[7 mm]

Quilting

Straight stitch

Appliqué

Outline stitch

Hachiware

Gusset
Outer fabric •
Lining
2 each

Appliqué for
first gusset

Appliqué for
second gusset

Quilting

approx. ¹/₄ in
[6-7 mm]

2³/₈ in
[6 cm]

2³/₈ in
[6 cm]

Sandwich loop

Pouch
Outer fabric • Lining
1 each

2³/₈ in
[6 cm]

Lobster
claw clasp
for strap

Black fabric
2 pieces

Fold the black fabric portion in half and stitch

Pouch
Outer fabric •
Lining
1 each

Outer fabric
1 each

Quilting

Straight stitch

Astonished Cat

Bottom
Outer fabric • Lining
1 each

¹/₄ in
[8 mm]

Quilting

Outline stitch

Straight stitch

French knot
stitch

Quilting

¹/₄ in
[8 mm]

Astonished Cat

2³/₈ in
[6 cm]

2³/₈ in
[6 cm]

2³/₈ in
[6 cm]

Astonished Cat

Gusset
Outer fabric • Lining
Mirrored pieces 1 each

Gusset

Zipper

approx. ¹/₄ in
[6-7 mm]

Quilting

Insert

Astonished Cat

Tail
Outer fabric
2 pieces

2⅛ in
[5.5 cm]

2⅛ in
[5.5 cm]

Pouch
Outer fabric •
Lining
1 each

2⅛ in
[5.5 cm]

Quilting

¹/₄ in
[7 mm]

Sandwich
loop

Appliqué

Straight
stitch

Outline
stitch

Appliqué

Siamese Cat

❧ Cat Clips on Pages 16–17 Finished size = 3⅜ x 4 in (8.5 x 10 cm)

Materials

Fabric Cat Clip (for one) Print fabric...7⅞ x 11¾ in (20 x 30 cm), Cotton tape ½ in (1.3 cm) width...4 in (10 cm), Buttons ½ in (1.3 cm) diameter...2, Flat bead 10 mm diameter...1, #5 Embroidery thread (mustard yellow)...small amount, Spring clamp (see Tips) 3⅛ in (8 cm) long...1, Cotton batting...small amount

Crochet Cat Clip (for one) Worsted yarn...as needed, Leather strap ⅛ in (3 mm) width (burnt brown)...4¾ in (12 cm), Button ¼ in (7 mm) diameter...2, Bead 7 mm diameter...1, Spring clamp (see Tips) 3⅛ in (8 cm) long...1, Cotton batting...small amount

Tools and other supplies

Crochet hook US H8 (Japanese 8/0 5mm), binding needle

Tips

• For the fabric cat clip, open the spring clamp and check the size against the template. The template shows the clamp in the open position.
• Spring clamps come in different shapes, styles and sizes, and are used for various purposes. Look for a tight grip at the nose, a relatively flat design and good proportions.
• Refer to the diagram to make the crocheted cat clip.

How to make

Fabric Cat Clip

1. With the body fabric pieces right sides facing, sandwich the piece of cotton tape between them. Sew all around, leaving an opening.

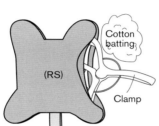

¼ in (5 mm)
(WS)
Opening
(RS)
2 in (5 cm)
Fold

Fold cotton tape in half and place in the tail position.

2. Turn right side out. Insert the clamp and fill the back section with cotton batting.

Cotton batting
(RS)
Clamp

3. Stitch opening closed.

(RS)

4. Sew the body and face the same way. Fill with batting and stitch opening closed.

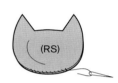

(RS)

5. Attach buttons and bead to face, embroider whiskers (see page 57 for embroidery techniques).

6. Sew face to body. Straight stitch

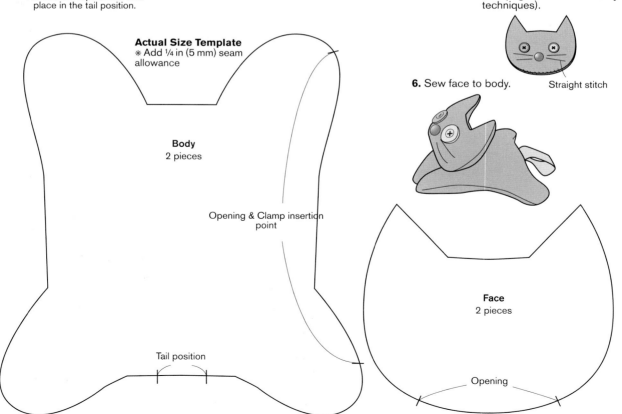

Actual Size Template
✻ Add ¼ in (5 mm) seam allowance

Body
2 pieces

Opening & Clamp insertion point

Tail position

Face
2 pieces

Opening

Crochet Cat Clip

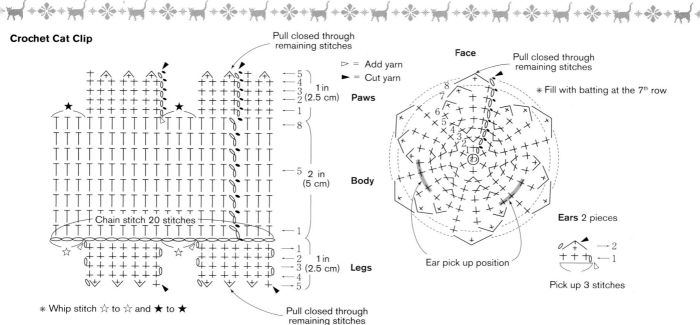

▷ = Add yarn
► = Cut yarn

Pull closed through remaining stitches

Paws
1 in (2.5 cm)

Body
2 in (5 cm)

Chain stitch 20 stitches

Legs
1 in (2.5 cm)

Pull closed through remaining stitches

✳ Whip stitch ☆ to ☆ and ★ to ★

Face

Pull closed through remaining stitches

✳ Fill with batting at the 7th row

Ear pick up position

Ears 2 pieces

Pick up 3 stitches

How to make

1. Insert the clamp from the leg portion of the body and fill with cotton batting.

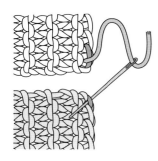

Whip stitch together

Cotton batting

2. Stitch the opening (☆ shown below) and legs closed.

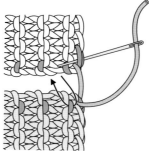

3. Sew buttons and bead to face, embroider whiskers (see page 57 for embroidery techniques).

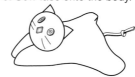

Straight stitch ① Yarn

4. Attach tail.

Legs

Fold the leather strap in two and tie the ends. Insert the looped side into the knitted fabric.

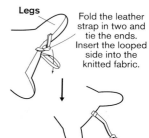

5. Sew face onto the body.

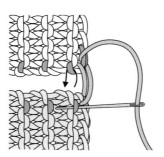

Garter stitch finish

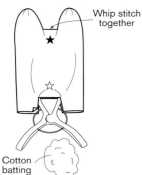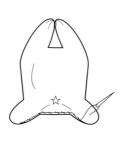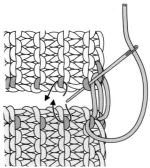

① Pick up the corner cast on stitch.

② Pick up the cast on stitch from the direct opposite side.

③ Pick up the closest inner stitch slightly beneath the edge on the bottom piece, then pick up the stitch slightly above the edge and parallel to the stitch you just picked up.

④ Continue picking up parallel stitches, alternating between the bottom and top pieces.

Cat Dolls on Pages 22–23

Finished size = **Large Black Cat** 11¾ in (30 cm) height, **Other Cats** 9⅞ in (25 cm) height

Materials

Large Black Cat Front fabric + Back fabric (linen wool)…13¾ x 19¾ in (35 x 50 cm), Tail fabric (wool)…2 x 7½ in (5 x 19cm) (cut on bias), Dress fabric (lace)…7⅛ x 15¾ in (18 x 40 cm), Undergarment fabric (wool)…5⅞ x 11¾ in (15 x 30 cm), Button ⅜ in (9 mm) diameter (white)…2, #25 Embroidery thread (brown · silver)…as needed, Elastic ¼ in (5 mm) width…5⅞ in (15 cm), Snaps ¼ in (7 mm) diameter…2 sets, Cotton batting, craft poly pellets…as needed

White Cat ✳ [] Indicates **Gray Cat**, unless otherwise specified, materials are the same

Front fabric + Back fabric (wool [linen wool])… 11¾ x 17¾ in (30 x 45 cm), Tail fabric (wool)…1⅝ x 5⅞ in (4 x 15 cm) (cut on bias), Dress fabric (print)…7⅛ x 12⅝ in (18 x 32 cm), Button ¼ in (7mm) diameter (white)…2, Square snap buttons ¼ in (6 mm) diameter…2
#25 Embroidery thread (burnt brown · silver [burnt brown])…as needed, Lace [Ribbon]…small amount, Snaps ¼ in (7mm) diameter…2 sets, Cotton batting, craft poly pellets…as needed

Tip

Search for extra cute fabric for the clothes, tie a ribbon around the neck, and thoroughly enjoy these "dress up" dolls.

How to make

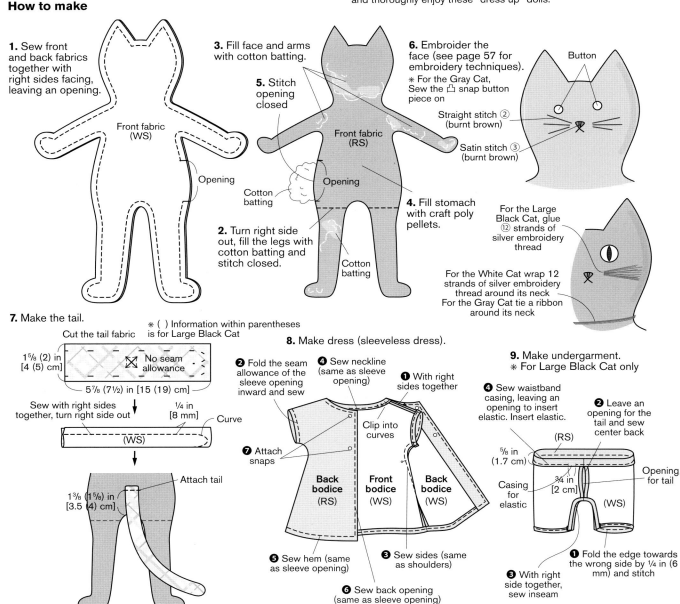

1. Sew front and back fabrics together with right sides facing, leaving an opening.

Front fabric (WS)

Opening

3. Fill face and arms with cotton batting.

5. Stitch opening closed

Front fabric (RS)

Opening

Cotton batting

2. Turn right side out, fill the legs with cotton batting and stitch closed.

Cotton batting

4. Fill stomach with craft poly pellets.

6. Embroider the face (see page 57 for embroidery techniques).
✳ For the Gray Cat, Sew the ☐ snap button piece on

Button

Straight stitch ② (burnt brown)

Satin stitch ③ (burnt brown)

For the Large Black Cat, glue ⑫ strands of silver embroidery thread

For the White Cat wrap 12 strands of silver embroidery thread around its neck
For the Gray Cat tie a ribbon around its neck

7. Make the tail.

✳ () Information within parentheses is for Large Black Cat

Cut the tail fabric

1⅝ (2) in [4 (5) cm]

No seam allowance

5⅞ (7½) in [15 (19) cm]

Sew with right sides together, turn right side out

¼ in [8 mm]

Curve

(WS)

1⅜ (1⅝) in [3.5 (4) cm]

Attach tail

8. Make dress (sleeveless dress).

❷ Fold the seam allowance of the sleeve opening inward and sew

❹ Sew neckline (same as sleeve opening)

❶ With right sides together

Clip into curves

❼ Attach snaps

Back bodice (RS)

Front bodice (WS)

Back bodice (WS)

❺ Sew hem (same as sleeve opening)

❸ Sew sides (same as shoulders)

❻ Sew back opening (same as sleeve opening)

9. Make undergarment.
✳ For Large Black Cat only

❹ Sew waistband casing, leaving an opening to insert elastic. Insert elastic.

❷ Leave an opening for the tail and sew center back

(RS)

⅝ in (1.7 cm)

Casing for elastic

¾ in [2 cm]

Opening for tail

(WS)

❶ Fold the edge towards the wrong side by ¼ in (6 mm) and stitch

❸ With right side together, sew inseam

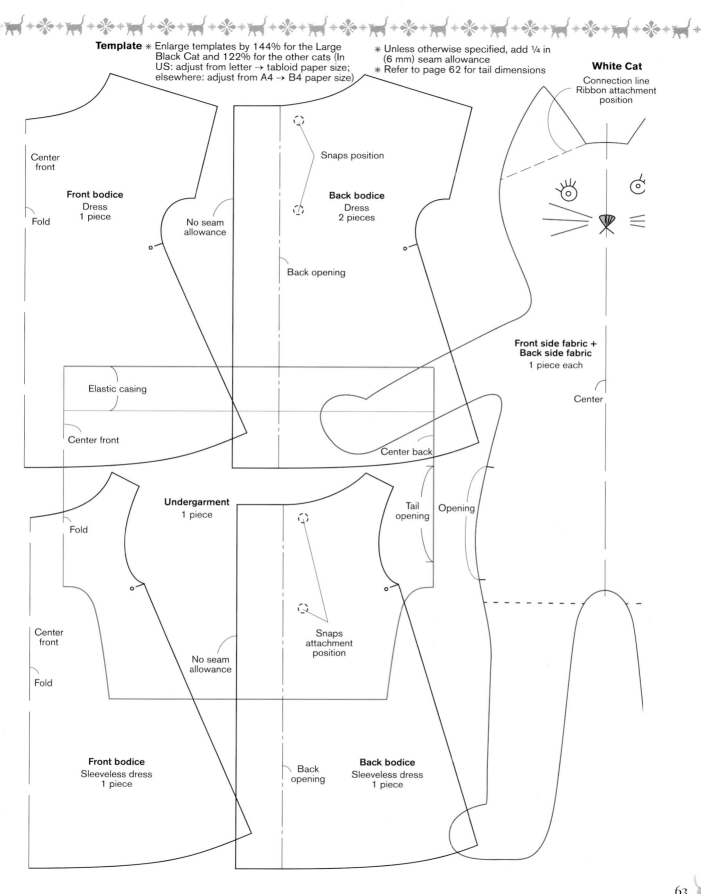

Template ∗ Enlarge templates by 144% for the Large
Black Cat and 122% for the other cats (In
US: adjust from letter → tabloid paper size;
elsewhere: adjust from A4 → B4 paper size)

∗ Unless otherwise specified, add ¼ in
(6 mm) seam allowance
∗ Refer to page 62 for tail dimensions

White Cat

Connection line
Ribbon attachment
position

Center
front

Front bodice
Dress
1 piece

No seam
allowance

Snaps position

Back bodice
Dress
2 pieces

Fold

Back opening

**Front side fabric +
Back side fabric**
1 piece each

Center

Elastic casing

Center front

Center back

Undergarment
1 piece

Tail
opening

Opening

Fold

Snaps
attachment
position

Center
front

No seam
allowance

Fold

Front bodice
Sleeveless dress
1 piece

Back
opening

Back bodice
Sleeveless dress
1 piece

❧ Cat-Shaped Door Stoppers on Pages 26–27 · Finished size = 13 ⅜ in (34 cm) height

Materials

Black Cat ✳ [] Indicates information for **Brown Cat**

Fabrics A + B…3½ x 7⅛ in (9 x 18 cm) each, Fabrics C + D…5⅞ x 7⅛ in (15 x 18 cm), Fabric E…5⅞ x 10⅝ in (15 x 27 cm), Fabric F…9 x 4¾ in (23 x 12 cm), Fabric G…5⅞ x 5⅞ in (15 x 15 cm), Fabric H…7⅞ x 2⅜ in (20 x 6 cm), Fabric I…4¾ x 4¾ in (12 x 12 cm), Felt (orange [black])…¾ x 1 in (2 x 2.5 cm), #25 Embroidery thread (red · light gray [dark gray · orange])… as needed, Button ¼ in (5 mm) diameter (red [orange])…2, Button ⅝ in (1.5 cm) diameter (gray [yellow])…1, Tyrolean trim tape ⅝ in (1.5 cm) width (red tones [black tones])…13¾ in (35 cm), Plastic bottle 16.9 oz (500 ml)…1, Nonwoven fabric bag…one that is approximately 11¾ x 17¾ in (30 x 45 cm) Sand…enough to fill plastic bottle, Cotton batting, Craft poly pellets, Rubber bands…as needed

Tip

Select a variety of fabrics such as corduroy, wool and felt to create a fun and eclectic patchwork.

Head
Fabric F
1 piece

Face
Fabric E
2 pieces

Actual Size Templates
✳ Add ⅜ in (1 cm) seam allowance to fabrics E and F
Add ¼ in (5 mm) seam allowance to fabric G
✳ Cut mirror shapes for fabric E

Ear
Fabric G
4 pieces

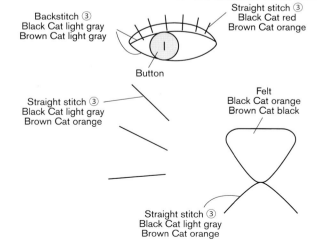

Backstitch ③
Black Cat light gray
Brown Cat light gray

Straight stitch ③
Black Cat red
Brown Cat orange

Button

Straight stitch ③
Black Cat light gray
Brown Cat orange

Felt
Black Cat orange
Brown Cat black

Straight stitch ③
Black Cat light gray
Brown Cat orange

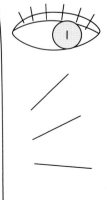

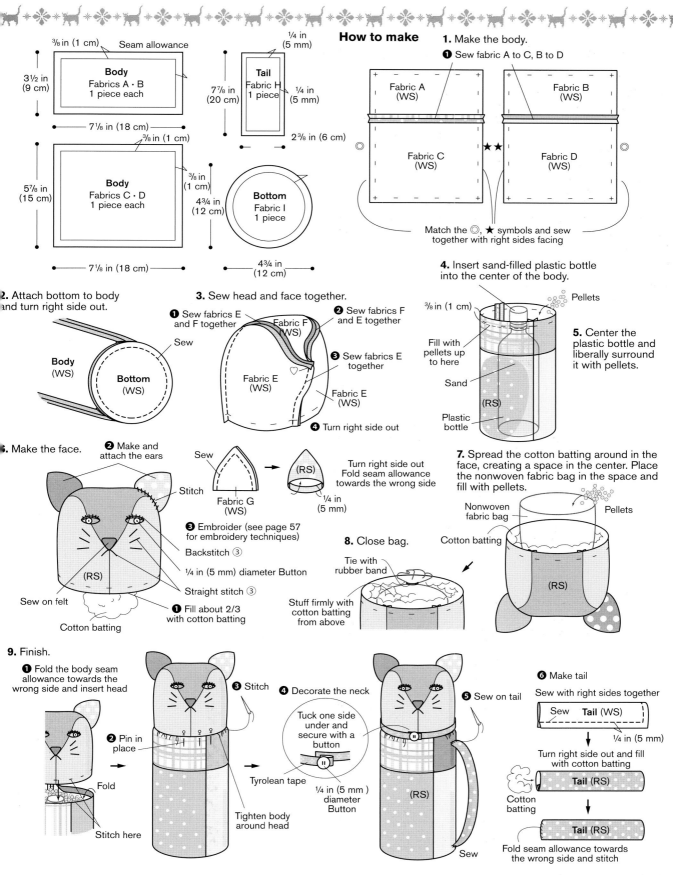

How to make

Seam allowance

3/8 in (1 cm)

Body
Fabrics A · B
1 piece each

3½ in (9 cm)

7⅛ in (18 cm)

3/8 in (1 cm)

Body
Fabrics C · D
1 piece each

5⅞ in (15 cm)

3/8 in (1 cm)

7⅛ in (18 cm)

¼ in (5 mm)

Tail
Fabric H
1 piece

7⅞ in (20 cm)

¼ in (5 mm)

2⅜ in (6 cm)

3/8 in (1 cm)

Bottom
Fabric I
1 piece

4¾ in (12 cm)

4¾ in (12 cm)

1. Make the body.

❶ Sew fabric A to C, B to D

Fabric A (WS)

Fabric C (WS)

Fabric B (WS)

Fabric D (WS)

★ ★

Match the ◎, ★ symbols and sew together with right sides facing

2. Attach bottom to body and turn right side out.

Body (WS)

Bottom (WS)

Sew

3. Sew head and face together.

❶ Sew fabrics E and F together

❷ Sew fabrics F and E together

Fabric F (WS)

❸ Sew fabrics E together

Fabric E (WS)

Fabric E (WS)

❹ Turn right side out

4. Insert sand-filled plastic bottle into the center of the body.

3/8 in (1 cm)

Pellets

Fill with pellets up to here

Sand

Plastic bottle

(RS)

5. Center the plastic bottle and liberally surround it with pellets.

6. Make the face.

❷ Make and attach the ears

Sew

Fabric G (WS)

(RS)

Turn right side out
Fold seam allowance towards the wrong side

¼ in (5 mm)

❸ Embroider (see page 57 for embroidery techniques)

Backstitch ③

¼ in (5 mm) diameter Button

Straight stitch ③

Stitch

Sew on felt

(RS)

Cotton batting

❶ Fill about 2/3 with cotton batting

7. Spread the cotton batting around in the face, creating a space in the center. Place the nonwoven fabric bag in the space and fill with pellets.

Nonwoven fabric bag

Pellets

Cotton batting

(RS)

8. Close bag.

Tie with rubber band

Stuff firmly with cotton batting from above

9. Finish.

❶ Fold the body seam allowance towards the wrong side and insert head

❷ Pin in place

Fold

Stitch here

❸ Stitch

❹ Decorate the neck

Tuck one side under and secure with a button

Tyrolean tape

¼ in (5 mm) diameter Button

Tighten body around head

❺ Sew on tail

(RS)

Sew

❻ Make tail

Sew with right sides together

Sew Tail (WS)

¼ in (5 mm)

Turn right side out and fill with cotton batting

Cotton batting

Tail (RS)

Tail (RS)

Fold seam allowance towards the wrong side and stitch

❧ Sketched Book Covers on Pages 24-25

Finished size = 6¼ x 12¼ in (16 x 31 cm) (standard paperback size; dimensions based on open book)

Materials

Cat Face + Bubbles outer fabric (aqua polka dots)…7⅞ x 15¾ in (20 x 40 cm), Lining fabric (linen)…7⅞ x 15¾ in (20 x 40 cm), #25 Embroidery thread (navy blue)…as needed, Cotton tape ¾ in (2 cm) width…7⅞ in (20 cm), Fabric tape ⅛ in (4 mm) width (beige) …9⅞ in (25 cm)

Book and Cat + Linen outer fabric (linen)…7⅞ x 15¾ in (20 x 40 cm), Lining fabric (dark blue)…7⅞ x 15¾ in (20 x 40 cm), #25 Embroidery thread (navy blue)…as needed, Cotton tape ¾ in (2 cm) width…7⅞ in (20 cm), Fabric trim tape ⅛ in (3 mm) width (burnt brown)…9⅞ in (25 cm)

Tip

Cat Face + Bubbles utilizes the printed bubbles for the embroidery. If you can't find a similar fabric, try adjusting the size when free-style stitching.

How to make

1. Cut outer fabric and lining fabric. Trace the template design on the outer fabric and embroider (see page 57 for embroidery techniques).

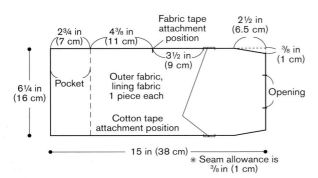

2. Sew outer fabric and lining with right sides together.

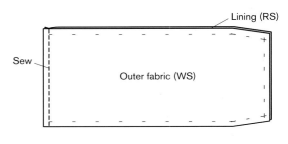

3. Turn right side out and press seams. For the 2¾ in (7 cm) section below, fold both the outer fabric and lining inward and press.

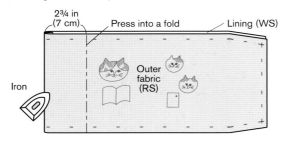

4. Turn wrong side out again, then fold in the section pressed in step 3.

5. Sandwich cotton and fabric tapes.

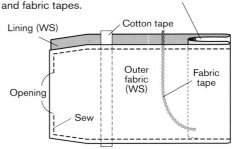

6. Sew all around, leaving an opening.

7. Turn right side out and stitch opening closed.

8. Make a decoration out of scraps.

Actual Size Template

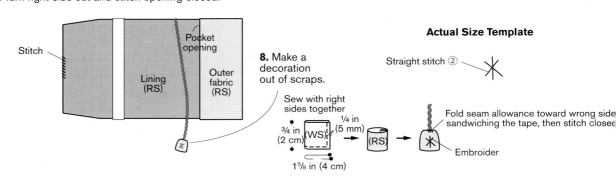

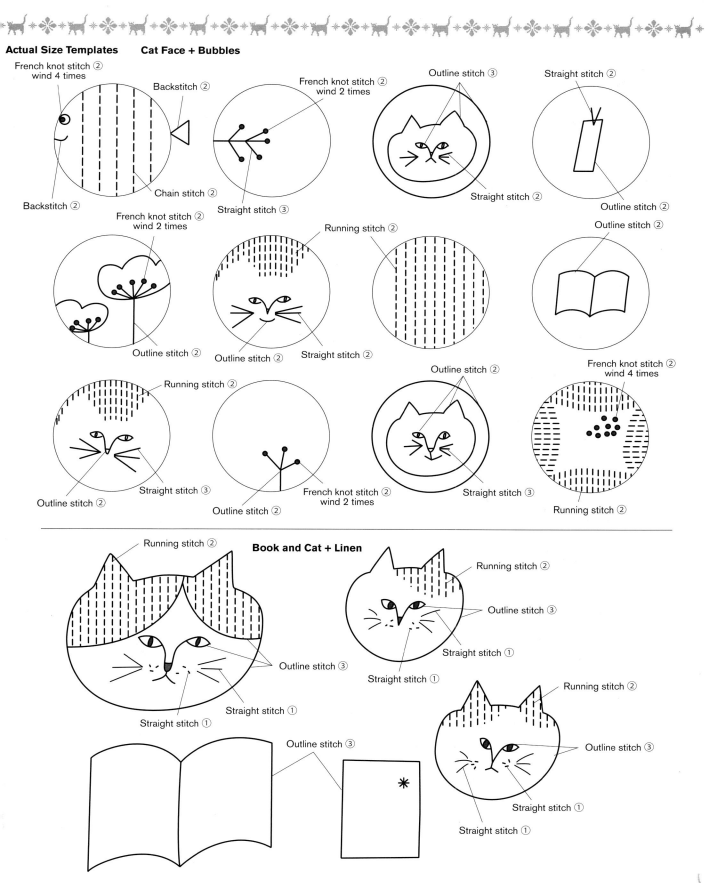

Actual Size Templates **Cat Face + Bubbles**

French knot stitch ②
wind 4 times

Backstitch ②

French knot stitch ②
wind 2 times

Outline stitch ③

Straight stitch ②

Backstitch ②

Chain stitch ②

Straight stitch ③

Straight stitch ②

Outline stitch ②

French knot stitch ②
wind 2 times

Running stitch ②

Outline stitch ②

Outline stitch ②

Outline stitch ②

Straight stitch ②

French knot stitch ②
wind 4 times

Running stitch ②

Outline stitch ②

Outline stitch ②

Running stitch ②

Outline stitch ②

Straight stitch ③

French knot stitch ②
wind 2 times

Straight stitch ③

Running stitch ②

Book and Cat + Linen

Running stitch ②

Running stitch ②

Outline stitch ③

Outline stitch ③

Straight stitch ①

Straight stitch ①

Straight stitch ①

Straight stitch ①

Outline stitch ③

Running stitch ②

Outline stitch ③

Straight stitch ①

Straight stitch ①

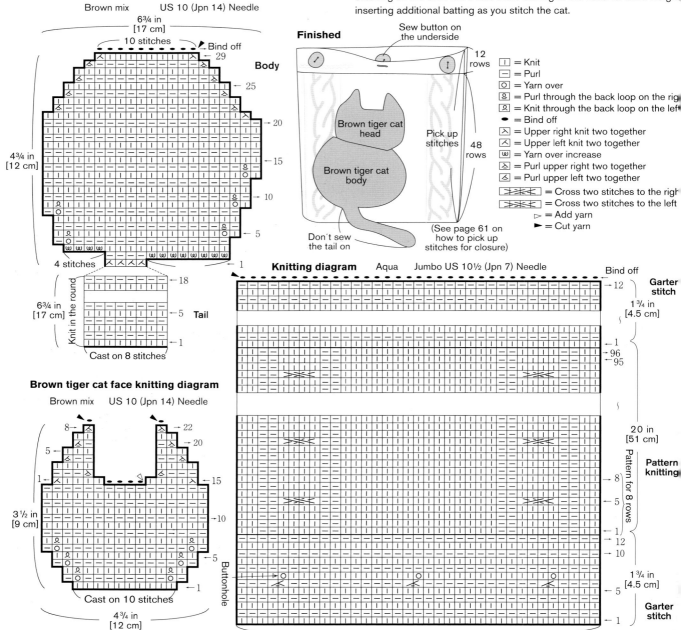

Knitted Pillows on Page 28

Finished size = 11¾ x 11¾ in (30 x 30 cm)

Materials

Extra thick yarn (such as DMC Natural XL Aqua)…6.7oz (190g), Mohair (brown mix) …35oz (10g), Cotton batting…small amount, Square pillow insert…11¾ in (30 cm)…1, Button 1 in (2.5 cm) diameter…3

Tools and other supplies

Knitting needles jumbo US 10½ (Japanese 7), US 10 (Japanese 14) (2 needles, 4 needles), binding needle

How to Make

• Finger cast on all stitches for first row.
• For the brown tiger cat tail, knit 8 stitches in the round, splitting the stitches into 4 per needle. Hold two of the needles parallel while knitting two upper left stitches together for the frontmost and immediately opposite stitches, then continue to knit the body.
• Fold the body in half with right side facing out and stitch sides closed.
• For the brown tiger cat, sew all parts of the body except the tail onto the pillow. Make sure to insert cotton batting to fluff it up before fully stitching on the cat. Add a little more batting to the head for extra weight, inserting additional batting as you stitch the cat.

Brown Tiger Cat Knitting Diagram

Brown tiger cat face knitting diagram

Finished

Sew button on the underside

Brown tiger cat head / Brown tiger cat body / Pick up stitches / Don't sew the tail on

Knitting diagram Aqua Jumbo US 10½ (Jpn 7) Needle

Legend:
□ = Knit
— = Purl
○ = Yarn over
= Purl through the back loop on the right
= Knit through the back loop on the left
● = Bind off
= Upper right knit two together
= Upper left knit two together
= Yarn over increase
= Purl upper right two together
= Purl upper left two together
= Cross two stitches to the right
= Cross two stitches to the left
▷ = Add yarn
► = Cut yarn

68 THE CAT LOVER'S CRAFT BOOK

Knitted Pillow on Page 28

Finished size = 11¾ x 11¾ in (30 x 30 cm)

Materials

Extra thick yarn (such as DMC Natural XL Beige)…6.7oz (190g), Worsted weight fancy yarn (black)…35oz (10g), #25 Embroidery thread (black)… as needed, Square pillow insert…11¾ in (30 cm)…1, Button 1 in (2.5 cm) diameter…3, Flat Beads 1 in (2.5 cm) diameter (yellow)…2, Barrel-shaped bead ⅝ in (1.5 cm) length (pink)…1

Tools and other supplies

Knitting needles jumbo US 10½ (Japanese 7 mm), knitting needles US 10 (Japanese 14), binding needle

How to Make

• Finger cast on all stitches for first row.
• Bind off to compete knitting.
• Fold the in half according to the diagram with right side facing out and stitch sides closed, leaving an opening up to the 6ᵗʰ row (see diagram).
• Sew on button at opening.
• Knit the black cat, then refer to diagram to sew onto pillow.

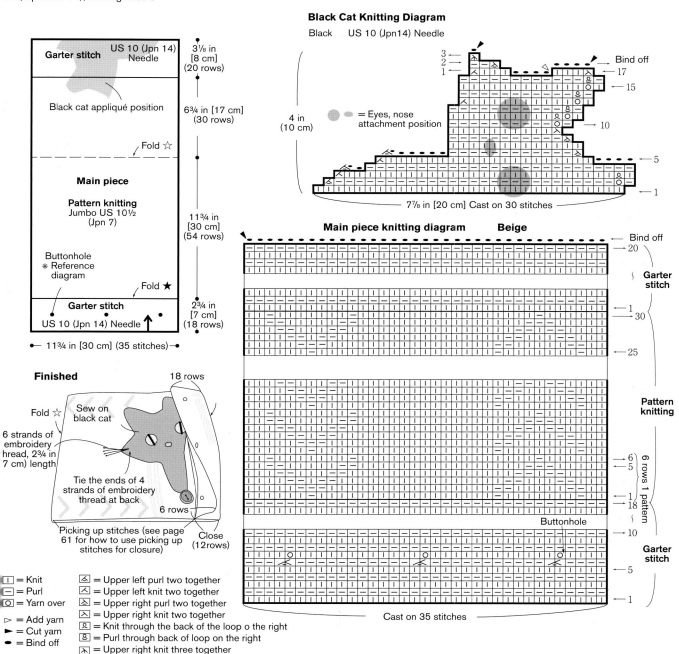

Black Cat Knitting Diagram

Black US 10 (Jpn14) Needle

= Eyes, nose attachment position

4 in (10 cm)

7⅞ in [20 cm] Cast on 30 stitches

Main piece knitting diagram **Beige**

Bind off

Garter stitch

Pattern knitting

6 rows 1 pattern

Buttonhole

Garter stitch

Cast on 35 stitches

Garter stitch — US 10 (Jpn 14) Needle
3⅛ in [8 cm] (20 rows)

Black cat appliqué position
6¾ in [17 cm] (30 rows)

Fold ☆

Main piece
Pattern knitting
Jumbo US 10½ (Jpn 7)
11¾ in [30 cm] (54 rows)

Buttonhole
* Reference diagram
Fold ★
2¾ in [7 cm] (18 rows)

Garter stitch
US 10 (Jpn 14) Needle

11¾ in [30 cm] (35 stitches)

Finished

18 rows

Fold ☆ Sew on black cat

6 strands of embroidery thread, 2¾ in (7 cm) length

Tie the ends of 4 strands of embroidery thread at back

6 rows

Picking up stitches (see page 61 for how to use picking up stitches for closure)

Close (12 rows)

☐ = Knit
⊟ = Purl
⊙ = Yarn over
▷ = Add yarn
► = Cut yarn
● = Bind off

= Upper left purl two together
= Upper left knit two together
= Upper right purl two together
= Upper right knit two together
= Knit through the back of the loop o the right
= Purl through back of loop on the right
= Upper right knit three together

❦ Patchwork Pillow on Page 29

Finished size = 11¾ x 11¾ in (30 x 30 cm)

Materials

Front fabric + Back fabric (cotton)…13¾ x 27½ in (35 x 70 cm), Piecework fabric (scraps)…about 10 assorted types as needed, Appliqué (Mohair fabric in beige · pink)…as needed, Yarn (worsted weight in 4 colors)…as needed, #5 Embroidery thread (off white · brown)…as needed, Zipper 12 in (30 cm length)…1, Button ¾ in (2 cm) diameter…1, Button ¼ in (7 mm) diameter…2, Pompom ⅝ in (1.5 cm) diameter (black)…4, Two-sided fusible interfacing…as needed

Tips

• For pieces A to J, start assembling from the center and extend outward. By starting and ending in this order, the stitches will be more stable.

• The coaching stitch is a method of outlining the shape with one embroidery thread, then embroidering the outline with another thread. Evenly spacing out the stitches will provide a clean finish.

How to make

1. Piece the face together to make the front side

❶ Add seam allowance for each piece

❷ Sew fabrics A – J in order

Sew A and B with right sides together, press seam allowance towards B

Press seam allowance towards the newly attached piece

Repeat sewing up to fabric J. ✳ Sew I and J together first, then connect to the others

Trim the seam allowance

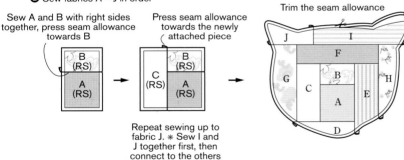

❸ Iron onto the front side of the pillow with two-sided fusible interfacing

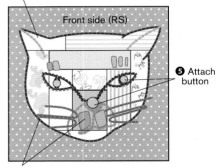

Front side (RS)

❺ Attach button

❹ Embroider and appliqué (see page 57 for appliqué techniques)

2. Insert zipper on the back side.

Sew

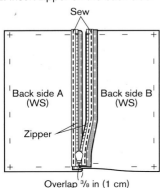

Back side A (WS)

Back side B (WS)

Zipper

Overlap ⅜ in (1 cm)

3. Sew front and back together with right sides facing.

Back side (RS)

Sew

Front side (WS)

4. Turn right side out from the zipper opening and add the pompom to the four corners.

Pompom

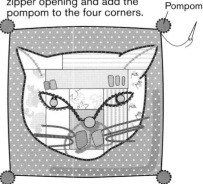

Templates

* Enlarge image by 122% (In US: adjust from letter → tabloid paper size; elsewhere: adjust from A4 → B4 paper size)
* Add ¼ in (7 mm) seam allowance to each piecework fabric before cutting out
* Use 1 strand for all embroidery thread
* Unless otherwise specified, use the coaching stitch; to tie the quilt, combine yarn + 2 strands of embroidery thread (off white); () parentheses indicate yarn color

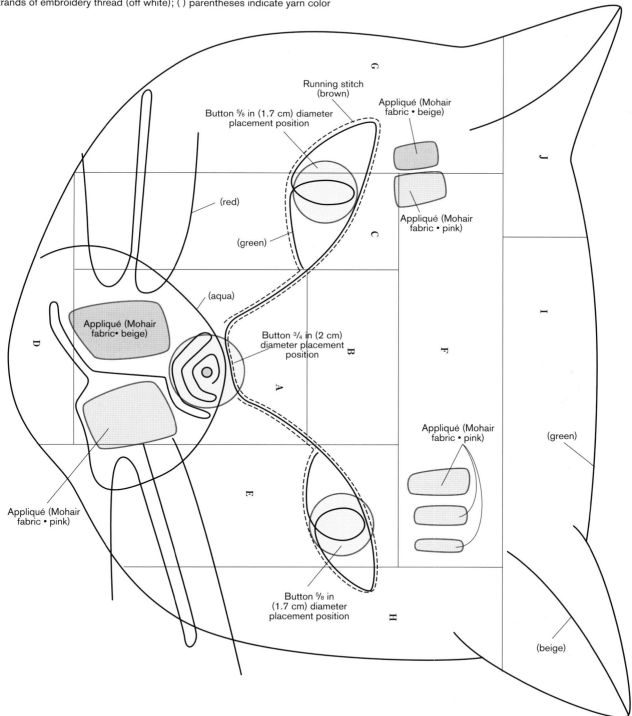

Running stitch (brown)

Button ⅝ in (1.7 cm) diameter placement position

Appliqué (Mohair fabric • beige)

Appliqué (Mohair fabric • pink)

(red)

(green)

G

C

J

(aqua)

Button ¾ in (2 cm) diameter placement position

B

F

I

Appliqué (Mohair fabric• beige)

D

A

Appliqué (Mohair fabric • pink)

(green)

Appliqué (Mohair fabric • pink)

E

H

Button ⅝ in (1.7 cm) diameter placement position

(beige)

Cuddly Cat Pillows on Pages 30-31

Finished size = 18⅛ x 15¾ in (46 x 40 cm)

Materials

Front side + Back side fabrics (lightweight denim)…14¾ x 17¾ in (35 x 45 cm) each, #25 Embroidery thread **Black Cat** (white, yellow, olive green); **Mackerel Tabby** (pink, brown, yellow)…as needed, Men's socks [feet size should be at least 7⅞ in (20 cm) in length]…1 pair, Cotton batting…as needed

Tip

Apply a steam iron to the completed embroidery for an extra crisp finish

How to make

1. Cut front and back fabrics. Trace the template onto the front side and embroider.

2. Sew front and back sides together with right sides facing, leaving an opening.

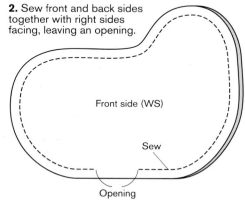

Front side (WS)

Sew

Opening

3. Turn right side out, fill with cotton batting and stitch opening closed.

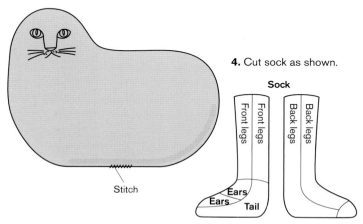

Stitch

4. Cut sock as shown.

Sock

Front legs / Front legs / Back legs / Back legs

Ears / Ears / Tail

5. Make the front legs, back legs and tail.
❶ Embroider all four legs (see page 57 for embroidery techniques)
(No embroidery on tail)

Outline stitch ⑥ (white [brown]) Make small stitches

Make rounded cuts

Front legs (RS)

❷ Sew with right sides facing
Sew
¼ in (6 mm)
(WS)

❸ Turn right side out and fill with cotton batting
Pull tight to close
Cotton batting

✳ [] Indicates information for Mackerel Tabby

6. Make ears.
❶ Fold so that the vertical and horizontal sizes are equal (see ○ symbol)

Fold / Fold

Ear fabric (WS)

Mountain fold
(RS)

❷ Fold edge and flip to front
(RS)
Flip to front from here
¼ in (6 mm) Sew

❸ Fill with cotton bating and stitch closed
Embroider *Same as legs
Stitch
❹ Make two of the same

7. Attach ears, legs and tail

Sew on
Sew on
Sew on

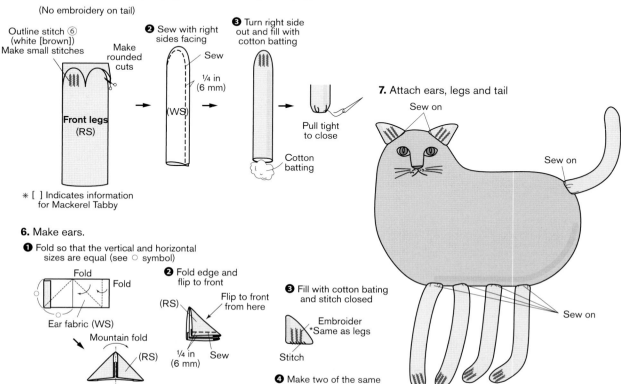

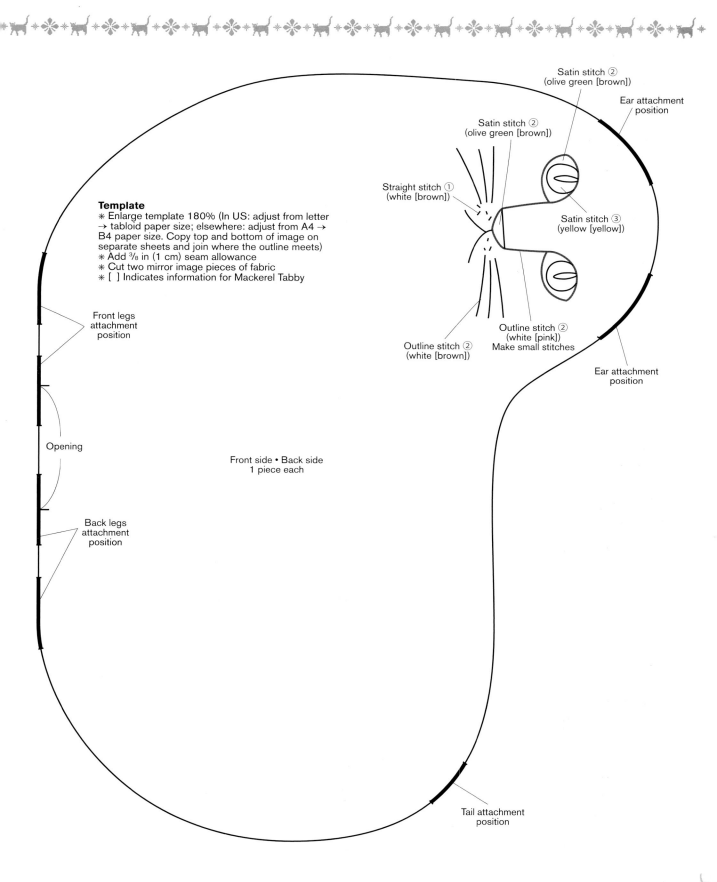

Template
* Enlarge template 180% (In US: adjust from letter → tabloid paper size; elsewhere: adjust from A4 → B4 paper size. Copy top and bottom of image on separate sheets and join where the outline meets)
* Add 3/8 in (1 cm) seam allowance
* Cut two mirror image pieces of fabric
* [] Indicates information for Mackerel Tabby

Front legs attachment position

Opening

Back legs attachment position

Front side • Back side
1 piece each

Satin stitch ②
(olive green [brown])

Ear attachment position

Satin stitch ②
(olive green [brown])

Straight stitch ①
(white [brown])

Satin stitch ③
(yellow [yellow])

Outline stitch ②
(white [pink])
Make small stitches

Outline stitch ②
(white [brown])

Ear attachment position

Tail attachment position

❧ Cat Pouch and Cat Pochette on Pages 32–33

Finished size = **Cat Pouch** 7⅛ x 7⅞ in (18 x 20 cm) (excluding handle); **Cat Pochettte** 7½ x 8¼ in (19 x 21 cm) (excluding handle)

Materials

Cat Pouch chunky yarn (orange mix)…1.6oz (45g), Fringe yarn (orange)…0.7oz (20g), D-ring…2, Leather handle ⅜ x 7½ in (1 x 19 cm)…1 set, Oval beads 1 in (25 mm) diameter (yellow)…2, Barrel-shaped bead ⅝ in (15 mm) length (pink)…1

Tools and other supplies

Knitting needles US10 (Japanese 13), binding needle Cat Pochette see page 44 for reference

How to Make

Cat Pouch
• Finger cast on 10 stitches, then refer to diagram to knit two faces.
• Sew together with wrong sides facing, using a whip stitch all around.
• Sew beads for eyes and nose on one side, embroider whiskers.
• Place a D-ring in each of the ear tips and attach handle.

Cat Pochette For detailed instructions, refer to pages 44-47.

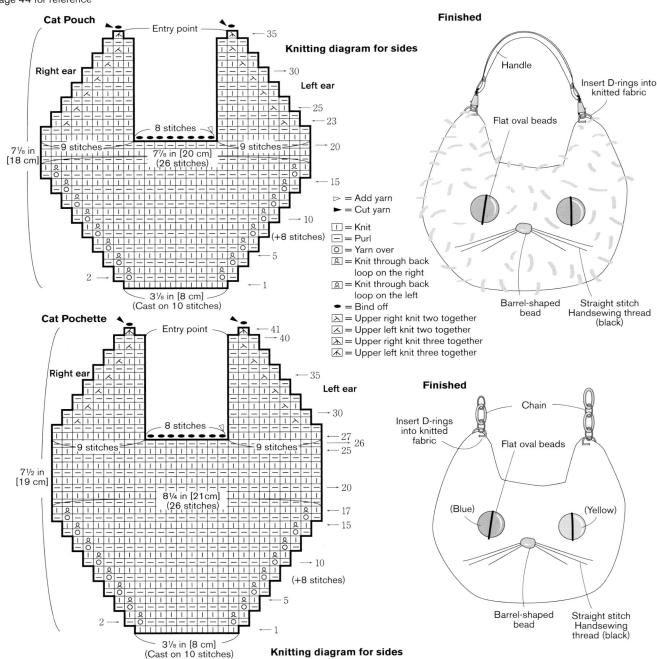

❧ Umbrella Handle Covers on Pages 38–39

Finished size = **Tiger Cat Paw** 9½ x 1⅜ in (24 x 3.5 cm); **Calico Cat Tail** 11 x 1⅛ in (28 x 3 cm); **Mackerel Tabby Tail** 10⅜ x 1⅛ in (26.5 x 3 cm)

Materials

Tiger Cat Paw See page 47 for reference
Calico Cat Tail, Mackerel Cat Tail light fingering weight yarn … 0.35oz (10g) in varigated brown (Calico) and gray (Tabby)

Tools and other supplies

Knitting needle US/Japanese 2, binding needle

How to Make

• See pages 44-47 for detailed instruction on how to make the Tiger Cat Paw.
• Finger cast on stitches and make the Calico Cat Tail using the twisted rib knit and the Mackerel Tabby Tail using 18 rows of garter stitch.
• Continue with 88 rows of stockinette stitch knitting. Refer to the diagram for stitch decreasing, and pull yarn through the remaining stitches to close.
• Pick up stitches for final closure.

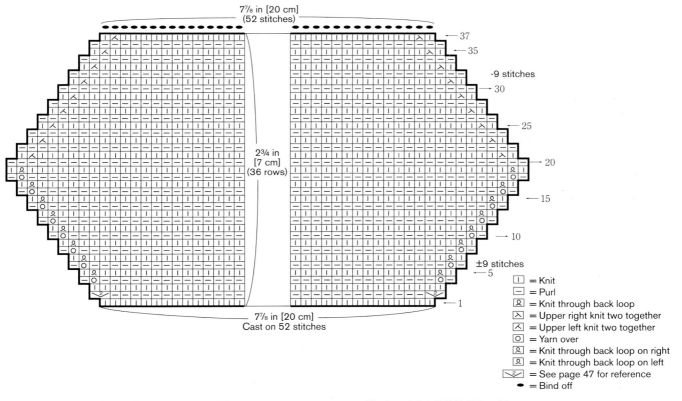

Tiger Cat Knitting Diagram

7⅞ in [20 cm]
(52 stitches)

← 37
← 35
-9 stitches
← 30
← 25
2¾ in [7 cm] (36 rows)
→ 20
← 15
← 10
±9 stitches
← 5
← 1

7⅞ in [20 cm]
Cast on 52 stitches

⊡ = Knit
⊟ = Purl
Ϙ = Knit through back loop
⋋ = Upper right knit two together
⋌ = Upper left knit two together
Ⓞ = Yarn over
Ϙ = Knit through back loop on right
Ϙ = Knit through back loop on left
∿ = See page 47 for reference
● = Bind off

Calico Cat Tail Knitting Diagram

4 stitches

← 5 ⎱ ⅜ in [1 cm]
← 1 ⎰
→ 88
→ 85 ⎱ 8⅝ in [22 cm]
← 1 ⎰
→ 18
⎱ 2 in [5 cm]
→ 2
← 1

2⅜ in [6 cm]
Cast on 20 stitches

Mackerel Cat Tail Knitting Diagram

4 stitches

← 5 ⎱ ⅜ in [1 cm]
← 1 ⎰
→ 88
→ 85 ⎱ 8⅝ in [22 cm]
← 1 ⎰
→ 18
⎱ 1⅜ in [3.5 cm]
→ 2
← 1

2⅜ in [6 cm]
Cast on 20 stitches

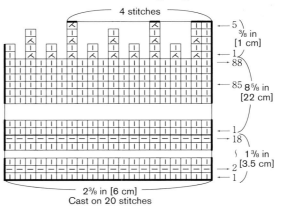

🐾 Cat Embroidered Bags on Pages 34–35

Finished size = **Walking Cat** 12⅜ x 9 in (31.5 x 23 cm) (excluding the handle); **Sitting Cat** 8⅞ x 9 in (22.5 x 23 cm)

Materials

Walking Cat outer fabric (navy blue) 25¼ x 9⅞ in (64 x 25 cm), Lining fabric (navy blue and white stripes) 26 x 9⅞ in (66 x 25 cm), Handle fabric (rose polka dot) 16½ x 4¾ in (42 x 12 cm), Fusible interfacing 15¾ x 3⅛ in (40 x 8 cm), #25 Embroidery thread (light gray, dark pink)…as needed, Button (pink) ¼ in (5 mm) diameter… 2
Sitting Cat outer fabric (red) 18⅛ x 9⅞ in (46 x 25 cm), Lining fabric (navy blue and white polka dot) 18⅞ x 9⅞ in (48 x 25 cm), Handle fabric (navy blue and white stripes) 16½ x 4¾ in (42 x 12 cm), Fusible interfacing 15¾ x 3⅛ in (40 x 8 cm), #25 Embroidery thread (navy blue)…as needed, Button (white) ¼ in (5 mm) diameter…2

Tip

The backstitch, considered one of the easiest stitches, is the main embroidery technique used for this project. Don't worry about getting it perfect; if your lines are a bit askew, it'll give the overall look some extra character!

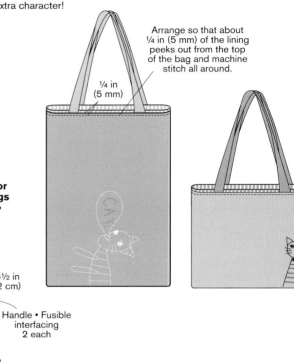

Arrange so that about ¼ in (5 mm) of the lining peeks out from the top of the bag and machine stitch all around.
¼ in (5 mm)

How to make

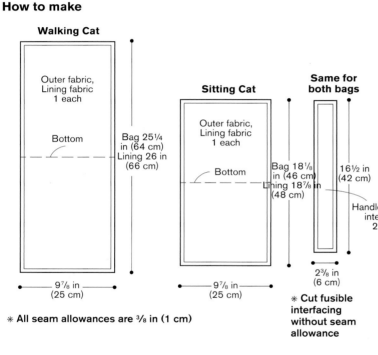

Walking Cat — Outer fabric, Lining fabric 1 each — Bottom — Bag 25¼ in (64 cm) Lining 26 in (66 cm) — 9⅞ in (25 cm)

Sitting Cat — Outer fabric, Lining fabric 1 each — Bottom — Bag 18⅛ in (46 cm) Lining 18⅞ in (48 cm) — 9⅞ in (25 cm)

Same for both bags — 16½ in (42 cm) — Handle • Fusible interfacing 2 each — 2⅜ in (6 cm)

✳ **Cut fusible interfacing without seam allowance**

✳ **All seam allowances are ⅜ in (1 cm)**

1. Iron on fusible interfacing to handles. Tuck in the seam allowance along the length of the handle and sew.

Sew (RS) — ⅜ in (1 cm) — ¾ in (2 cm)

2. Baste handles to embroidered outer bag.

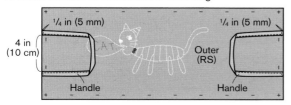

¼ in (5 mm) — ¼ in (5 mm) — 4 in (10 cm) — Outer (RS) — Handle — Handle

3. With right sides together, sew outer bag and lining along short edges.

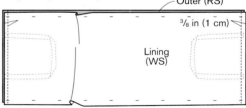

Outer (RS) — ⅜ in (1 cm) — Lining (WS)

4. Fold the outer bag and lining as shown and sew sides, leaving an opening. Turn right side out from the opening and stitch opening closed.

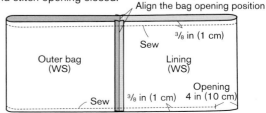

Align the bag opening position — ⅜ in (1 cm) — Sew — Outer bag (WS) — Lining (WS) — Sew — ⅜ in (1 cm) — Opening 4 in (10 cm)

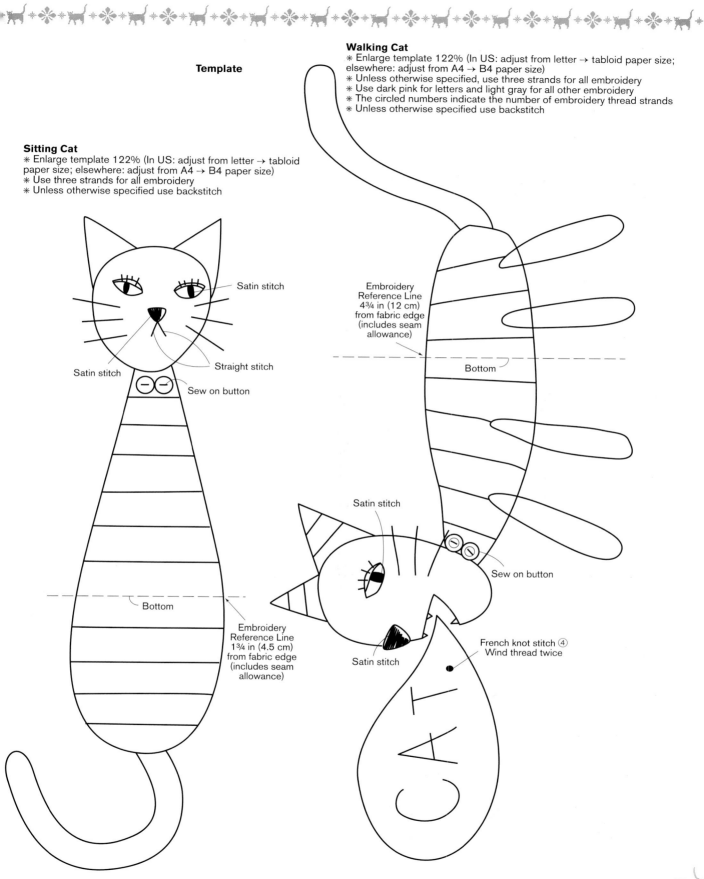

Template

Walking Cat
∗ Enlarge template 122% (In US: adjust from letter → tabloid paper size; elsewhere: adjust from A4 → B4 paper size)
∗ Unless otherwise specified, use three strands for all embroidery
∗ Use dark pink for letters and light gray for all other embroidery
∗ The circled numbers indicate the number of embroidery thread strands
∗ Unless otherwise specified use backstitch

Sitting Cat
∗ Enlarge template 122% (In US: adjust from letter → tabloid paper size; elsewhere: adjust from A4 → B4 paper size)
∗ Use three strands for all embroidery
∗ Unless otherwise specified use backstitch

Satin stitch

Satin stitch

Straight stitch

Sew on button

Embroidery Reference Line 4¾ in (12 cm) from fabric edge (includes seam allowance)

Bottom

Satin stitch

Sew on button

Bottom

Embroidery Reference Line 1¾ in (4.5 cm) from fabric edge (includes seam allowance)

Satin stitch

French knot stitch ④ Wind thread twice

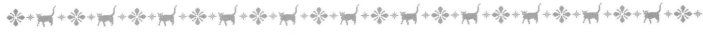

❧ Catryoshka Pouches on Pages 36–37

Finished Size = **Large** 7½ x 6¾ in (19 x 17 cm) **Medium** 5½ x 5⅛ in (14 x 13 cm) **Small** 4⅜ x 4 in (11 x 10 cm)

Materials

Large Fabric for body (felt in moss green) 7⅞ x 13¾ in (20 x 35 cm), Lining fabric (print) 7⅞ x 15 in (20 x 38 cm), Appliqué fabric (felt in white, beige, golden yellow, vermilion, yellow green, green) as needed, Zipper 9 in (22 cm) length, Buttons – One each in the following sizes: ⅞ in (2.3 cm) diameter, apple-shaped ⅝ in (1.6 cm) diameter, dome shank ½ in (1.4 cm) diameter

Medium Fabric for body (felt in vermilion) 5⅞ x 11 in (15 x 28 cm), Lining fabric (print) 6¾ x 12⅝ in (17 x 32 cm), Appliqué fabric (felt in white, golden yellow, yellow green, vermilion, green) as needed, Zipper 7 in (17 cm) length, Buttons –: ⅜ in (1 cm) diameter x 2; dome shank ¼ in (8 mm) diameter x 1

Small Fabric for body (felt in golden yellow) 4⅜ x 8¼ in (11 x 21 cm), Lining fabric (print) 5⅛ x 9½ in (13 x 24 cm), Appliqué fabric (felt in white, vermilion, green, light gray) as needed, Zipper 5 in (13 cm) length, Buttons ⅜ in (1 cm) diameter x 2; flat shank ⅜ in (1 cm) diameter x 1, #25 Embroidery thread…as needed of coordinating colors

Tips

• Appliqué the parts of the face and the pocket with a ladder stitch. Use stitching and secure flowers and leaves with a button to give dimension.
• Use felt scraps from the body to create the flower and leaf shapes, creating various color combinations to your liking.

How to make

1. Appliqué and embroider on the front and back of body (see page 57 for embroidery techniques).

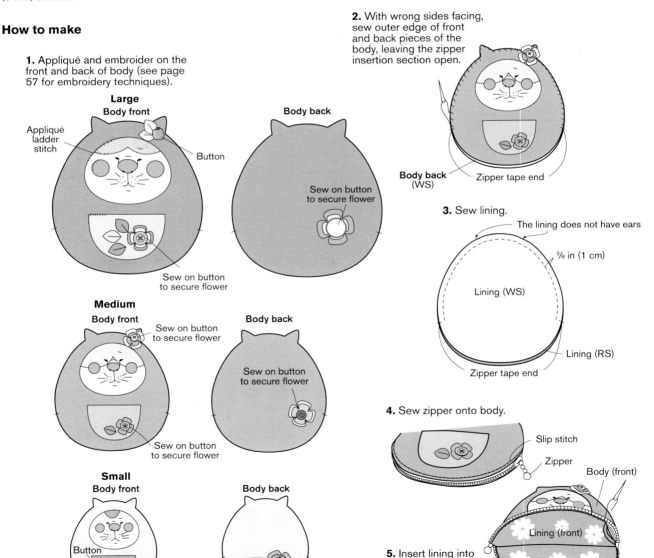

Large
Body front
Appliqué ladder stitch
Button
Body back
Sew on button to secure flower
Sew on button to secure flower

Medium
Body front
Sew on button to secure flower
Body back
Sew on button to secure flower
Sew on button to secure flower

Small
Body front
Button
Body back
Sew on button to secure flower

2. With wrong sides facing, sew outer edge of front and back pieces of the body, leaving the zipper insertion section open.

Body back (WS)
Zipper tape end

3. Sew lining.

The lining does not have ears
⅜ in (1 cm)
Lining (WS)
Lining (RS)
Zipper tape end

4. Sew zipper onto body.

Slip stitch
Zipper
Body (front)

5. Insert lining into the outer body and stitch along the zipper tape.

Lining (front)

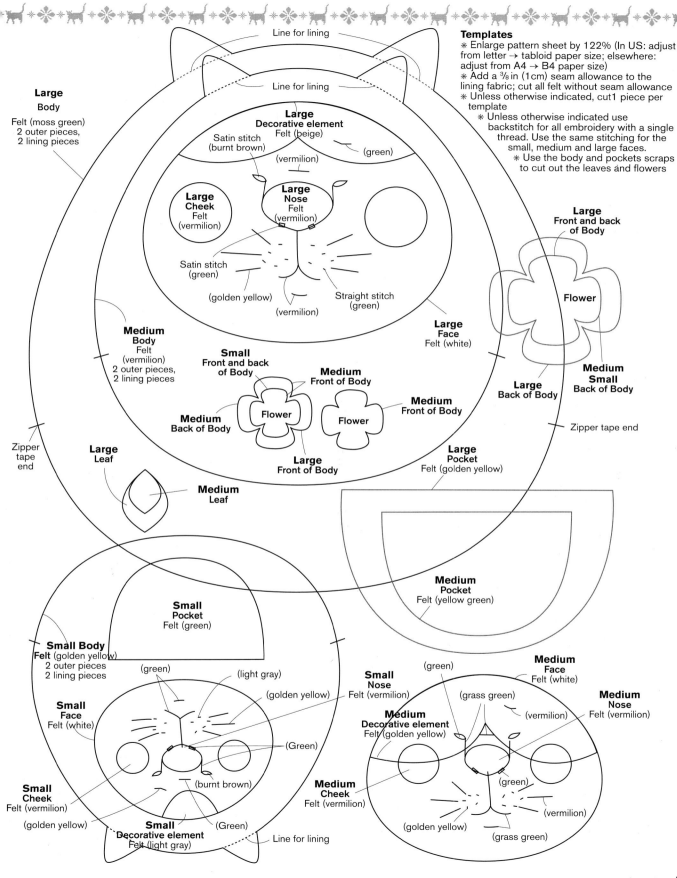

Templates

∗ Enlarge pattern sheet by 122% (In US: adjust from letter → tabloid paper size; elsewhere: adjust from A4 → B4 paper size)
∗ Add a ⅜ in (1cm) seam allowance to the lining fabric; cut all felt without seam allowance
∗ Unless otherwise indicated, cut1 piece per template
∗ Unless otherwise indicated use backstitch for all embroidery with a single thread. Use the same stitching for the small, medium and large faces.
∗ Use the body and pockets scraps to cut out the leaves and flowers

Line for lining

Line for lining

Large
Body

Felt (moss green)
2 outer pieces,
2 lining pieces

Large
Decorative element
Felt (beige)

Satin stitch
(burnt brown)

(vermilion)

(green)

Large
Cheek
Felt
(vermilion)

Large
Nose
Felt
(vermilion)

Satin stitch
(green)

(golden yellow)

Straight stitch
(green)

(vermilion)

Large
Face
Felt (white)

Large
Front and back
of Body

Flower

Medium
Small
Back of Body

Large
Back of Body

Medium
Body
Felt
(vermilion)
2 outer pieces,
2 lining pieces

Small
Front and back
of Body

Medium
Front of Body

Medium
Back of Body

Flower

Medium
Front of Body

Flower

Medium
Front of Body

Large
Front of Body

Large
Pocket
Felt (golden yellow)

Zipper tape end

Zipper
tape
end

Large
Leaf

Medium
Leaf

Medium
Pocket
Felt (yellow green)

Small
Pocket
Felt (green)

Small Body
Felt (golden yellow)
2 outer pieces,
2 lining pieces

(green)

(light gray)

(golden yellow)

Small
Nose
Felt (vermilion)

Small
Face
Felt (white)

(Green)

Medium
Face
Felt (white)

(green)

Medium
Decorative element
Felt (golden yellow)

(grass green)

Medium
Nose
Felt (vermilion)

(vermilion)

Small
Cheek
Felt (vermilion)

(burnt brown)

Medium
Cheek
Felt (vermilion)

(green)

(golden yellow)

(Green)

Small
Decorative element
Felt (light gray)

Line for lining

(golden yellow)

(vermilion)

(grass green)

Published by Tuttle Publishing, an imprint of Periplus Editions (HK) Ltd. 2018

www.tuttlepublishing.com

Neko Sugei (NV70354)
Copyright © NIHON VOGUE-SHA 2016
All rights reserved:
Photographer: Yukari Shirai, Yuki Morimura
Designers of the projects in this book: Yumi Oami, Mico Ogura, Miyuki Hayashi, Chizuko Kojima,
Miwako Ozawa, Naoko Suzuki, Kyoko Maruoka, Yoko Kobayashi, Hitomi Hanaoka, rie, Kanade Isshiki,
Marupoleland, Mitsuno Watanabe
Styling / Kaori Maeda
Book Design / Fumie Terayama
Assistant Editors / Yoshiko Ando, Chihiro Nishida, Hiroko Ubukata
Editing coordinator / Natsuko Sugawara
Editor/ Tomomi Ishigami
Any sale of articles made from the designs in this book is strictly prohibited.

English translation righs arranged with NIHON VOGUE Corp. through Japan UNI Agency, Inc. Tokyo
Translated from Japanese by Sanae Ishida
English Translation ©2018 Periplus Editions (HK) Ltd.

ISBN: 978-4-8053-1492-0

Distributed by:
North America, Latin America & Europe
Tuttle Publishing
364 Innovation Drive, North Clarendon
VT 05759-9436 U.S.A.
Tel: 1 (802) 773-8930; Fax: 1 (802) 773-6993
info@tuttlepublishing.com; www.tuttlepublishing.com

Japan
Tuttle Publishing
Yaekari Building, 3rd Floor
5-4-12 Osaki, Shinagawa-ku, Tokyo 141 0032
Tel: (81) 3 5437-0171; Fax: (81) 3 5437-0755
sales@tuttle.co.jp; www.tuttle.co.jp

Asia Pacific
Berkeley Books Pte. Ltd.
61 Tai Seng Avenue #02-12, Singapore 534167
Tel: (65) 6280-1330; Fax: (65) 6280-6290
inquiries@periplus.com.sg; www.periplus.com

22 21 20 19 18 10 9 8 7 6 5 4 3 2 1
Printed in China 1805RR

ABOUT TUTTLE "Books to Span the East and West"

Our core mission at Tuttle Publishing is to create books which bring people together one page at a time. Tuttle was founded in 1832 in the small
New England town of Rutland, Vermont (USA). Our fundamental values remain as strong today as they were then—to publish best-in-class books
informing the English-speaking world about the countries and peoples of Asia. The world has become a smaller place today and Asia's econom-
ic, cultural and political influence has expanded, yet the need for meaningful dialogue and information about this diverse region has never been
greater. Since 1948, Tuttle has been a leader in publishing books on the cultures, arts, cuisines, languages and literatures of Asia. Our authors
and photographers have won numerous awards and Tuttle has published thousands of books on subjects ranging from martial arts to paper crafts.
We welcome you to explore the wealth of information available on Asia at **www.tuttlepublishing.com**.

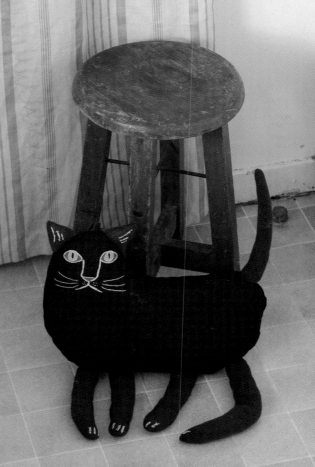

The CAT LOVER'S CRAFT Book

NEKO SHUGEI

TUTTLE Publishing

Tokyo | Rutland, Vermont | Singapore

Introduction

Why are cats so cute? Is it their fluffy, cuddly fur? Or their unwavering, gentle yet piercing stare? *The Cat Lover's Craft Book* is a collection of delightful handmade projects featuring these beguiling creatures that so effortlessly capture the heart. We've included a little embroidery here, a bit of knitting there, and a whole variety of other techniques to make many kinds of kitties. Relax and playfully enjoy the process of crafting up your very own darling kitty.